T0196053

When We Pray

8 Meditations on the Aesthetics of Prayer & the Spiritual Life

Written and Illustrated By

Damon A. Powell, Ph.D.

BALBOA.
PRESS

A DIVISION OF HAY HOUSE

Balboa Press books may be ordered through booksellers or by contacting:

Balboa Press
A Division of Hay House
1663 Liberty Drive
Bloomington, IN 47403
www.balboapress.com
1 (877) 407-4847

ISBN: 978-1-9822-2012-9 (sc)
ISBN: 978-1-9822-2013-6 (e)

Library of Congress Control Number: 2019900575

Print information available on the last page.

Balboa Press rev. date: 01/31/2019

Dedication

No one walks alone along this journey. Each of us stands alongside and upon the shoulders of countless others. I stand in this truth, acknowledging the many friends and fans who have given words of encouragement, financial support, and listening ears as I labored to manifest this project. Your praise and appreciation for the *When We Pray* series, and your desire to see the completed project kept me going when the task appeared to be beyond my reach.

Contents

Acknowledgments

I give thanks and appreciation to Mother for always pushing me to believe that I could achieve anything I put my mind to.

Michael, you have always been there when I needed you. Thank you for opening your home to me yet again. You are a true friend indeed.

Joe, you believed in me when many others had written me off. Your friendship is essential to my soul.

A word of recognition to the men of the Omega Psi Phi Fraternity, Incorporated, who have filled my life with friendship and brotherhood.

The honest but caring critiques and listening ear provided by the men and women of the NVisible Atelier artists' group have been invaluable and inspiring.

I acknowledge and bow before the spirit of all creation and the guides whom you sent to work with me. And so it is. Ashe'

Preface

The inspiration for the prose contained in *When We Pray* came about as a result of a series of images I created with the same title. The decision to expand upon the series came about during the creation of the seventh image, when Spirit filled me with a desire to elaborate upon the visual imagery by discussing specific insights that had come about as a result of the creation process. I wanted to use these images as a point of entry from which to expound upon the feelings and insights that had come to me through my research and engagement in the creation of the series. Since they served as the inspiration for the prose, I thought it only fitting for those very same images to serve as the introduction to each chapter.

Each chapter opens with an image followed by a brief meditation on a topic related to art, aesthetics, prayer, and the spiritual life. These meditations contain insights from a variety of sources, ranging from my prayerful observations and personal experiences to significant concepts from my research and truths that I have downloaded from Spirit during my spiritual practices. I have defined any technical terms and included them in a glossary located behind the final chapter. Although each meditation can stand on its own, I recommend reading chapter one, "Making the Connection," before you begin to skip around through chapters two through seven. The final section, "Coda: There Is Only Love" will be best appreciated after reading through a few of the other chapters. However, these are mere recommendations; as with all things, follow your intuition.

Feel free to pick a chapter to focus on or peruse the illustrations. I have provided a brief discussion of my inspiration for creating the images, some insights into the symbolism within them, and a brief description of the medium used in their creation in the Illustrations section below. Reading through it might help as you view the images, but the most important interpretation is always that which they communicate to you. *When We Pray: Eight Essays on the Aesthetics of Prayer and the Spiritual Life* is more than a picture book showcasing the works of an artist; it is meant to be a complementary package containing imagery and insightful prose that nourishes the eyes, mind, and spirit. *Namaste'*

The Illustrations

I created the cover and interior illustrations for *When We Pray*. The images that introduce each chapter were created as part of an eight-piece series that is also entitled *When We Pray (1-8)*. The inspiration for the initial image was conceived during meditation practice. Afterward, I was nudged toward the creation of a second image and given a brief flash of imagery that was to serve as the next inspiration. A few weeks later, another and another...until the process culminated with the final eighth image, *"When We Pray VIII: There is Only Love."*

Each image contains symbols from various cultural or religious traditions. These symbols express a truth within that tradition or some of its most significant ideals. In some instances, I have combined symbols from more than one tradition in ways that enhance the image's overall meaning. The hands in each image symbolize the divine hand or hands, shielding, supporting, caressing, blessing the central figure as she or he engages in the act of prayer and meditation. The aura surrounding the figures is indicative of spiritual light and power emanating from within.

All the images were created using a medium called scratchboard. Scratchboard is a drawing medium that utilizes a thin piece of board covered with a white clay substance. The clay-covered board is then coated with ink or dye and allowed to dry. Once the ink is dry, the image is scratched out of the ink using various types of blades to reveal the white clay underneath. Scratchboard is a subtractive process in which the artist creates the image by removing from the surface rather than adding layers upon it.

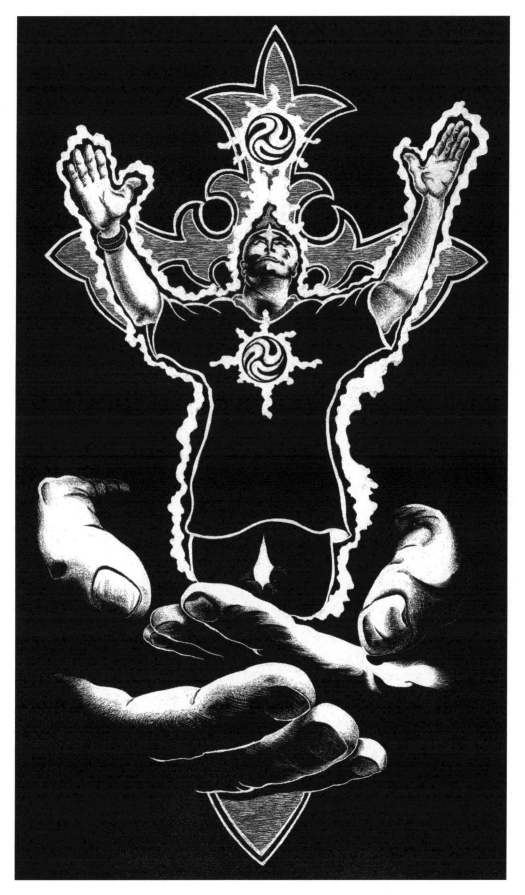

When We Pray I

Making the Connection
Prayer, Aesthetics, and the Spiritual Life

M any might consider prayer, aesthetics, and the spiritual life to be odd subjects to combine and I would agree. There is no specific point along my life's trajectory that I can point to and say, "This is where it all began." My interests in these subjects and the connections between them originated as many things in life do: from a sneaking suspicion. From an inner feeling, a whisper, a subconscious inkling that there was something hidden deep within that was waiting to be not just discovered, but apprehended. In time, this inkling germinated. It began to make its presence known to my conscious awareness in ways that were both irritating and mysterious. Like feeling a tiny pebble in your shoe that you keep looking for but can't find. Or noticing an unfamiliar shadow in the corner of your room. You keep staring at it intently because you know something's there, but no matter how hard you stare you can't bring it in to focus.

Eventually, my intuition about these connections began to speak so loudly that it became a quiet inner knowing. I sensed there were connections, but I lacked the knowledge and skills needed to articulate my intuitions. I needed to manifest them so that they could become both psychically and physically real. It is this desire that pushed me to become a theologian. After entering the ministry and completing my Master of Divinity, I could have just continued along the path of pastoral ministry. But the voice inside my head had ceased whispering and was now loudly calling out to me from the mountaintops just beyond the edge of my horizon. So, I decided to cross the valley and attempt to climb the mountain.

Like many in the Western world, I was introduced to aesthetics through the world of art. If the term "aesthetics" enters conversation, it is commonly associated with discussions related to the visual arts and philosophical notions regarding the nature of beauty or artistic taste. In the Western tradition, these associations are traced back to the writings of ancient Greek philosophers. Although appreciating the beautiful is the most well-known aspect of aesthetic theory, it is only one facet of a much broader field of inquiry that has expanded and transformed throughout Western history. One of the reasons beauty has remained such an important aspect of aesthetic theory is because of its power to overwhelm and captivate us. Even the idea of beauty is beautiful. The arts can create and convey beauty, so it is no coincidence that any discussions about beauty or aesthetics would eventually have to include them. Unlike the beauty found in nature, the beauty encountered in the arts is decidedly

more subjective. Few people would find a sunrise ugly or grotesque, but many might find a artist's visual interpretation of one not to their liking. The subjective aspects of artistic beauty are at least partially responsible for the development of theories regarding artistic taste in the Western tradition. "The Beautiful," whether natural or fabricated, always engages the senses.

Sensual experience is the primary factor that grounds art and beauty into the bedrock of aesthetics. In its broadest context, aesthetics is primarily concerned with sensory perception. Sight, touch, taste, sound, and smell are the building blocks for all human experience. As infants, touch is the first sense encountered within the womb. It paves the way for the development of our individuation as selves as we begin to perceive the boundaries of our bodies from those encountered in the world around us. Our capacity to distinguish between what is "me" and what is "not me" helps to form the core of all other mental constructs. Sensory perception is essential to human experience, and experience and perception are aesthetic. Since art and beauty must be perceived, they lie within the domain of aesthetic theory. However, aesthetic theory is not just about sensory perception but also about our ability to receive and process the information provided by our senses. Our passive senses, such as touch, hearing, and smell, are always open with or without our conscious awareness, but the concern of aesthetics is with that which is not only received but actively *perceived* and processed through conscious awareness. One of the reasons beauty has always been at the forefront of aesthetics is because of its ability to be consciously perceived and processed by the mind, body, and spirit. The sensations we receive when beholding the beautiful are so powerful that we can easily remember and relive them. Beauty's power creates a readily available resource for any discussion about sensory phenomena, conscious awareness, our ability to process these phenomena, and their effects.

The data that beauty provides is ever-present and ever-fertile, but it cannot be mimed until it has first been intimately experienced and successfully apprehended. "The Beautiful" is so overwhelmingly powerful that it can be easily perceived, but it is not so easily integrated or understood. Apprehension is an essential component in the aesthetic process because it enables us to discern the place and meaning of beauty in our world. Aesthetics, art, and spirituality are essential to humanity because of their ability to help us interpret and then express our values to the world. Throughout human history, all of

Damon A. Powell, Ph.D.

humanity has expressed an unending thirst and constant search for meaning. Every culture is an expression of that society's values as they are developed through the establishment of art, political structures, religious beliefs, and other cultural expressions. But these structures could not exist without the creation of just, ethical, and philosophical conclusions about the nature and character of physical and spiritual reality.[1] The data and perspectives you hold regarding the divine, self, and others have powerful and direct connections to the way you interact with the world around you. The conclusions you make regarding these topics become your life's guiding principles. These ultimate values comprise the ethical roadmap that will undergird every choice you make about the proper way to act, interact, or relate to others and the world around you.

For example, if you conclude that the world is a cruel and hostile place, you will be much more likely to advocate and commit acts of violence, as you have already concluded that you should be afraid and that this hostile environment requires that you do whatever it takes to ensure survival for yourself, your race, your country, etc. You will more than likely interact with others from a place of initial mistrust, defensiveness, and a willingness to abandon or cut alliances if it appears that they might hinder your chances for survival. The acquisition and exercise of unilateral power will be of great importance to you, and you will admire those who you believe possess it. Your image of the divine will more than likely have been impregnated with images of power, vengeance, wrath, domination, war, control, retribution, or other similar concepts. You will be likely to judge yourself and your relation to others based upon personal power and your ability to dominate or exert your will and influence upon them. You will be prone to strive for dominance and have little tolerance for any perceived weakness in yourself or others. The natural world, from this perspective, is not a welcoming place but rather a cause for fear and anxiety. Other beings are to be conquered or dominated, and their lives will most assuredly be deemed of lesser value. While this example is an oversimplification, many of the positions expressed within it are accurate reflections of the ultimate values we encounter within our contemporary world.

Similarly, the apprehension of beauty can provide insight into the ultimate value of both physical and spiritual reality. An encounter with that which is truly beautiful is so powerful that it not only captivates but, in many instances,

overwhelms the senses. Our ability to perceive such beauty is itself a wonder. Such powerful sensory input can produce equally powerful emotions. These experiences are uplifting; they lift us and fill us with indescribable sensations and emotions. Joy, love, oneness, peace, ecstasy, light, hope, exhilaration, and a host of other emotions are all part of beauty's powerful allure. This uplifting is referred to in theological circles as anagogy. The truly beautiful is not just a sensual or emotional experience, but a spiritual one as well. The anagogical is not just a sensory uplifting but an uplifting that moves us to such a degree that we are carried up into the higher vibrations of Spirit. Experiencing beauty lifts us into the realms of the eternal. "The Beautiful" touches every aspect of our being, and in doing so, it both lifts and changes us with its touch. Such powerful experiences provide ample fodder for philosophical, spiritual, and aesthetic examination. This uplifting is the reason why beauty and aesthetics have become intimately linked to the spiritual. The anagogic states experienced by an encounter with "The Beautiful" are the very same states associated with religious or spiritual experiences like bliss, ecstasy, transcendence, deep inner peace, inner illumination, joy, love, or enlightenment. These states invoke sensations and emotions, and center around our relations to self, the divine, and others. These feelings and relations spring from our perceptions and the conclusions we arrive at based upon those perceptions. These feelings are what renders them aesthetic and transcendent.[2]

The experience of transcendence has played a more prominent role in theological and philosophical discussions of beauty because of its connection to "The Good" and "The True, and "The Good, "The True," and "The Beautiful are known as "The Transcendentals." These three exist in direct relation to one another and are often apprehended simultaneously. When not encountered together, their existence is often still interdependent.

Let us begin the articulation of this phenomenon by considering "The Beautiful." The anagogic power of beauty leads one to sense the presence of "The Good" and "The True." That which we deem beautiful we often also deem good, true, and trustworthy. That which we find true and trustworthy we also deem good. That which is good must also be true, or it could not be good.

As "The Good" reveals its truth, we also encounter its beauty. As we encounter goodness and truth, we also encounter their inherent beauty. This transcendental triad leads us to the recognition of ethical and virtuous

Damon A. Powell, Ph.D.

qualities as a direct result of our experience with them. They take us higher and transform us as a result of the experience. As we lift vibrationally, we can then transcend the normal limits of human perception and gain access to the supra-sensuous. The insights we obtain from this level of awareness are distinctly different from those in everyday life. These distinctions are the reasons behind the powerful and captivating nature of these impressions. Their distinct difference from our "normal" experience creates a brief but drastic spike above our usual range of perception, touching mind, body, and soul so deeply they cannot be forgotten.

Prayer is practiced universally among countless spiritual and religious traditions. It is the most common and most relied upon activity for opening oneself to communication with the divine. As we go within through practices like prayer and meditation, we sharpen our senses and their ability to perceive and receive higher levels of sensual experience. As our senses become more attuned to higher levels of perception, the fabric of our everyday life becomes richer. Also, we have lifted to such a degree that anagogic states become far more frequent and consistent in our life experience. Prayer and other practices allow us to develop and heighten what the colonial exhorter Jonathan Edwards referred to as the "spiritual senses." In the Christian context, these senses were acquired by the believer as a byproduct of the conversion experience and its accompanying spiritual awakening.[3] These spiritual senses are the means by which the soul would develop and strive to ever-higher levels of virtue, beauty, and grace. The states Edwards speaks of are anagogic and reflect our ability to access the supra-sensuous. This access touches our lives and changes us in slight ways that progressively shift and expand our consciousness into the higher states we describe as enlightenment.

The occurrence of these enlightened states in both the spiritual and creative realms is the context for my interest in this seemingly odd combination. Spirituality can exist without art or religion, but religion cannot exist for long without art or spirituality. The art world apparatus has managed to exclude discussions of spirituality or religion from art, but it has been unable to dissociate itself from the captivating spirituality of beauty. As an artist, I feel the movement of Spirit whenever I engage deeply in the creative process. As I began to explore and deepen my spirituality through prayer and meditation, I recognized the feelings I had in those moments as similar and often identical to those I experience during the creative process. My studies in undergraduate

art history reminded me that for most of humanity's history art was created for religious and spiritual purposes. The deeper I delved into theology, the more confident I became that none of this was a coincidence. Initially, I lacked the tools needed to articulate what mind and spirit were confirming. I eventually came to a point in time when I could no longer accept the discontent my ignorance was creating within me. I looked toward the horizon and saw a gigantic mountain whose summit was shrouded by clouds. Somewhere from that summit, a still, small voice was whispering out to me. I began to move forward, but a deep and enormous valley blocked my path. I decided to embark on the long and difficult journey to cross the valley and attempt to climb the mountain. I can now hear the whisper more clearly. But I still have so much further to climb.

1 Leroi Jones, Home: Social Essays (New Jersey: Ecco Press, 1998), 212.
2 Earle J. Coleman, Creativity and Spirituality: Bonds between Art and Religion (Albany: State University of New York Press, 1998), 188.
3 John E. Smith, Harry S. Stout, and Kenneth P. Minkema eds, A Jonathan Edwards Reader (New Haven: Yale University Press, 1995), 141.

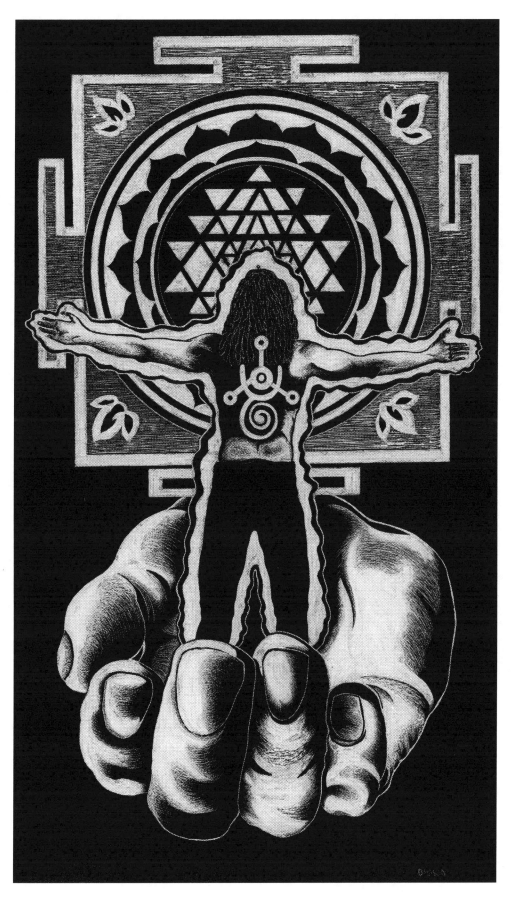

When We Pray 2

The Aesthetics of Enlightenment
The Universal and the Particular

When the word "aesthetics" pops up in contemporary circles, most of us associate it with theories regarding how we perceive and understand beauty. This is a very limited perception that merely props the door open. If we open the door fully, we are invited into a much broader landscape that grounds aesthetics in the realm of sensory experience. Our senses are essential to this discussion because beauty must be perceived before it can be experienced, and perception is impossible without engaging the senses. You *see* a beautiful work of art; you *hear* beautiful music, you *taste* a beautiful meal, you *feel* the power of nature, physically and emotionally. Beauty, at its most fundamental level, is a celebration of the sensual that can act as a prerequisite to the wider range of aesthetic experience. "Aesthetics" is derived from the Greek root *aesthesis* which can best be defined as "of the senses" or "perceptible by the senses." When the founder of the discipline, Alexander Baumgarten, coined the term "aesthetics," his original intention was to establish a scientific method for the study of empirical experience.[1] If beauty provides a window through which we can glimpse what's on the other side, aesthetics opens the door to invite us into an exploration of sensory perception and the nature of human embodiment.

Far too many of us live disembodied lives. We are rarely fully present to our experiences due to living in the past, worrying about the future, overmedicating, overindulging, blocking or denying our feelings, and ignoring or neglecting our bodies until we reach the end of our lives without ever having fully lived them. Unfortunately, many of our religious and spiritual traditions do more to reinforce this tendency toward disconnection than encourage healthy and affirming attitudes toward embodiment. We learn that the body is bad, sinful, part of the reason we suffer and a host of other negative assertions. However, embodiment is essential because it is through the locus of our bodies that we perceive and experience this reality. As we increase our capacity for embodiment, we increase our capacity to feel and perceive the information that our senses are constantly feeding us, which also heightens our ability to enjoy life itself. As we become more fully embodied, we also find that we can be more present to our experiences, thus intensifying experience while simultaneously decreasing stress, since we are able to acknowledge and release that which we deem negative much more quickly and easily. We can only truly know what we can perceive, and we can only perceive through our senses. Sensual perception ensures that all experience is sensuous, embodied experience.

In response to this assertion, some may argue that there are experiences that refute this claim: during deep states of meditation, epiphanies, out-of-body experiences, or drug-induced altered states. But I would counter: if you perceived it, you felt it; and if you felt it, it was sensory and embodied. If you are here on this plane and have an experience of this kind, it was perceived by your senses from the supra-sensual. If you are still here afterward to remember it, speak about what you felt, saw, or heard during the experience; it is embodied. To deny this reality is to deny the body-soul-spirit connection. While our spirits are interconnected with our bodies, every aspect of our perception is a sensual experience because Spirit communicates to us through the sensory phenomena we perceive.

Science now reinforces this claim by proving that every perception we have is accompanied by a corresponding physical sensation that has been stored in the body as cellular memory. Whether it is a thought, an experience, or a feeling, it is perceived by the brain and the body as sensory data and recorded and stored within the cellular memory—whether we are consciously aware of the experience or not. This finding supports psychological theories which discuss trauma, post-traumatic stress disorder, post-traumatic slave syndrome, recalling experiences in the womb while under hypnosis, and practices such as the curing of ailments through body awareness practices and improving intuition through muscle testing. This process of cellular encoding renders all human experience sensory, embodied, and aesthetic.

If all experience is aesthetic, then the paths to enlightenment, nirvana, and the road to heaven must all be paved with sensory experience. If we are to walk this path, we must first define what we mean by enlightenment. Enlightenment is not a destination to be reached nor a threshold that one must pass through. Enlightenment is a blossoming, a progressive unfolding of insight and revelation into the nature of universal, divine, consciousness. This perspective moves us away from misguided notions that perceive enlightenment as a prize to be obtained, goal to be accomplished, or destination to be reached. This mindset is much too static. A more nuanced perspective allows us to envision a progressive and ongoing revelation of consciousness that moves us through the sensual toward the supra-sensual, until we eventually become one with pure consciousness. The movement toward enlightenment is one of relative degree and expansion into the vastness of all that is. From this perspective, Muhammad, Jesus, Buddha, and Confucius were all enlightened persons who

Damon A. Powell, Ph.D.

have now moved on to continue their expansion on other vibratory planes. Their consciousness has expanded beyond the particularities of the physical plane. The apostle Paul reminds of this in 2 Corinthians when he points out, "We have this treasure in earthen vessels."[2]

These "earthen vessels" or "jars of clay" serve as reminders that our existence is grounded in particularity. Each of has a singularly unique body, existing in a particular point in history, in a specific location, within a particular ethnic group, and so on. To be in the physical world is to exist in specificity and particularity. However, we somehow know that these "jars of clay" contain a priceless treasure that is so much more than what we see each morning in the mirror. Each of us possesses an inner sense, an innate knowing, a feeling of connection to something that is above and beyond our particularity; and that "treasure" is the universal. The universal is always contained within the particular. Knowledge can only be revealed to us through our senses. In moments of relaxation and stillness, or in the presence of nature…connection to all there is. They convey the knowledge that we are more than just our bodies – and this perception is aesthetic. Science has only recently begun to catch up to what our senses, philosophers, and religious figures have been telling us for thousands of years, that we are inexplicably connected to all that is. Science now tells us that everything is energy; we knew that. Science now says that a single cell contains everything needed to produce a complete human being; we knew that. Science now says that we are composed of the same elements contained in the stars; we knew that, too. We have known these things for centuries. The manner through which we came to these conclusions has no basis in the scientific method, but it was still very much evidence-based. Evidence obtained through the exercise of sensuous embodied practices promoting deeper levels of embodiment. *"We have this treasure in earthen vessels."*

The universal is recognized within the particular. The path to enlightenment is aesthetic. Aesthetic experience is sensuous and embodied. In other words, we must dig for the treasure! If you are going to dig a hole, you start at the surface and go progressively deeper; this is the path of enlightenment. If we want to truly know and experience the universal or move toward more enlightened states, we must delve more deeply into our unique particularity. This realization is both paradoxical and counterintuitive. We are told to avoid pain; ignore, deny or suppress negative emotions; distrust our senses or intuition; and to neglect

or ignore our bodies, but in the long run these attitudes do more to increase our suffering and promote further disembodiment than they could ever do to support resolving our feelings of disembodiment. Our refusal to truly be in our bodies and be one with our experiences allows our current level of dysfunction to persist. Our goal is to become more fully human by delving more deeply into our senses so that we can learn the lessons they have to impart. What if, instead of ignoring or resisting our feelings, we embraced them, interrogated them, or simply acknowledged them and allowed them to be what they are? What if we truly listened to our bodies regarding what we should eat, when we should sleep, or in what kind of exercise we should engage?

The aesthetics of enlightenment calls for us to embrace our embodiment in all its particularity and, in doing so, we progressively encounter more and more of that which is authentically and eternally universal. Our spirits came to this plane for reasons, one of which is to absorb and bask in the contrasting and lush sensory perceptions that this world has to offer. Any movements toward deeper levels of embodiment are movements toward greater levels of psycho-bio-spiritual integration. The path *to* is the way *through*. Practices that promote deeper levels of body awareness or allow us to experience broader vistas of perception usher us along the path toward enlightenment. As we go more deeply within and allow ourselves to be open to the particularities of our perceptions, we begin to encounter a spacious inner landscape which is far more vast and rich than we could have possibly imagined. The deeper within we go, the richer our daily experience becomes. We can then carry more of that eternality with us into our everyday lives, which in turn allows us to be more present and mindful to our experiences and perceptions, thereby enriching the quality of our lives and heightening our sense of embodiment.

If we are to find the treasure Paul reminds us of, we must be willing to dig for it. We must be ready and willing to get down on our hands and knees and dirty ourselves in the soil of life. Within this soil we find the true purpose for living—to dig deep into the ground of existence, to struggle to be present to our lives and all the experiences along the way. Rather than avoid, neglect, or ignore that which we find painful or unpleasant, we must run toward it if we can—or at least be willing to authentically feel it—trusting that this too is part of the path: to sit with these experiences; acknowledge and be with these feelings; and, to the degree that we can, embody them. No matter how minute or seemingly insignificant, nothing in life or nature has ever been

wasted. Too many of us have become content walking on the surface of life's experiences. We spend our entire lives never going below the topsoil. But the treasure is always buried deep. What we fail to realize is that this failure to dig into the depths of our particularity drastically affects our ability to experience and appreciate the heights of the universal as well. All of life becomes grey and bland to such a degree that we end up convincing ourselves this is all there is. Until one day, something so overwhelming comes along that we are forced to pay attention.

Our senses and the corresponding feelings that accompany them are not messy hindrances on the path to enlightenment; they are the building blocks upon which we walk the path. Our bodies and the boundaries that form them are the instruments through which we encounter the universal. Everything that we hear, feel, taste, touch, and see helps to form the sensorimotor building blocks of our consciousness. The body never lies, and it never forgets. We are sensuous embodied beings and the raw sensory data we gather from our experiences is the key to connecting with that which lies beyond us in the realms of the supra-sensuous. There is a direct correlation between sensuous perception, emotional feeling, and spiritual sensitivity. Just as certain skills must be developed and practiced, so must our ability to access the universal. By cultivating these embodied aesthetic practices, we hone our ability to recognize and appreciate the divine as it is being manifested within our daily lives.

Consistently practicing the art of embodiment through practices like meditation, Tai Chi, or yoga helps us to progressively maintain this awareness in other aspects of our daily lives. These intentional explorations into our bodies and the senses they possess heighten our ability to consciously gather information from our senses and to remain embodied under more difficult life circumstances. We can be more fully present in every aspect of our experience in the present moment. More fully being in what Eckhart Tolle calls "the Now" heightens our senses but also opens the door to an interior spaciousness accompanied by peace, resilience, and a feeling of connection to something beyond us. This spaciousness feels light and expansive. As we become more comfortable living our lives from this place, we are more able to tune in to the subtler aspects of our life experiences in ways we may have never been able to before. There is a physical, emotional, and energetic sensitivity that begins to develop and blossom. From this sensitivity, a greater capacity for gratitude develops and ushers us along the path toward progressive enlightenment.

One of the most commonly practiced forms of disembodiment lies within the realm of our emotions. Many of us were taught that our emotions are to be feared, suppressed, ignored, or seen as a weakness; nothing could be further from the truth. Our emotions are to be valued and treasured above all else, because they provide us with a wealth of information about ourselves, others, and the suprasensuous. Emotions are expressions of the energy being manufactured and transmitted by the body to provide us with information. If we ignore these messages, we not only miss out on a wealth of valuable data but also run the risk of causing serious damage to both our physical bodies and our psycho-spiritual matrix. If every sensation and emotion is recorded in our cellular memory, continually suppressing this energy will inevitably result in poor health outcomes. Psycho-spiritually these acts of suppression block our ability to: think coherently, stunt our ability to feel empathy and compassion for ourselves and others, and clog the channels of our intuition, thereby hindering our ability to access the suprasensuous, and hindering our ability to experience life with true depth and profundity.

Being present to our emotions is tantamount to being present to life. Being present is especially important when experiencing the most painful or difficult emotions. Emotional pain can at times be so strong and overwhelming as to feel unbearable. But as we cultivate the ability to be more present to our senses and the feelings that accompany them, we also develop a greater capacity for resilience, and a willingness to sit with those emotions that we fear could overwhelm us or threaten our very sanity. Time is just time. It does not heal; it merely covers and buries. It is what you do with and in that time that can make a world of difference. This approach is counterintuitive because our body and mind teach us to avoid and retract from pain to help us preserve our lives, but when dealing with emotional pain in particular, the path *through* is the way to healing. If we allow ourselves to feel and be present to these emotions by acknowledging them and letting them pass through us, we tap into a current that will take us more deeply into the universal and further strengthen our connection to the divine within us.

The spiritual medium and self-proclaimed "Spiritual Indiana Jones" Jonette Crowley teaches a technique called "Soul Body Fusion" which provides some interesting insights related to the mind, body spirit connection.[3] In Soul Body Fusion, the intention is to integrate the spirit and soul with the physical body more fully. Jonette says that the fusion process permanently alters cellular

DNA so that the receiver is more able to hold higher levels of spiritual energy within the physical body, thus increasing the receiver's overall vibration and heightening sensory perception.[4] To receive the transmission, she asks that the receiver sit still with their hands on their lap, palms-up, eyes closed. She instructs them not to meditate, but to simply be open to the process while maintaining their intention to allow soul, body, and spirit to fuse. During this time, the receiver sits quietly, focusing on their body. Spirit uses this time to more fully fuse itself with the soul and physical body. In this process, the universal can more thoroughly ground itself within the particular. The results of this fusion provide the receiver with a host of benefits that increase with continued practice. But the essence of the work is to focus upon simply being present to and one with the physical body, to feel whatever comes up without judgment, fear, or any attempts to distract one's self from sensory experience. in this way, Spirit or the universal has the latitude to fully integrate into our being (the particular).

Conversely, if we want to more fully connect and integrate the universal into our physical being and consciousness, we must delve more deeply into our senses and the awareness they can bring us. We can only work with what we have and start from where we are. By diving more deeply into the particulars of our being and working with and through our senses, we can progressively discover and embody that which is universal. These star-dusted clay jars do indeed contain a universal treasure.

1 Richard Shusterman, "Aesthetic Experience: From Analysis to Eros" The Journal of Aesthetics and Art Criticism 64, no. 2 (Spring 2006), 218.

2 2nd Corinthians 4: 7 (New Revised Standard Version.)

3 Jonette Crowley, "Soul Body Fusion". website for the Center for Creative Consciousness, https://centerforcreativeconsciousness.com/soul-body-fusion-2/. (accessed August 12, 2018).

4 Ibid.

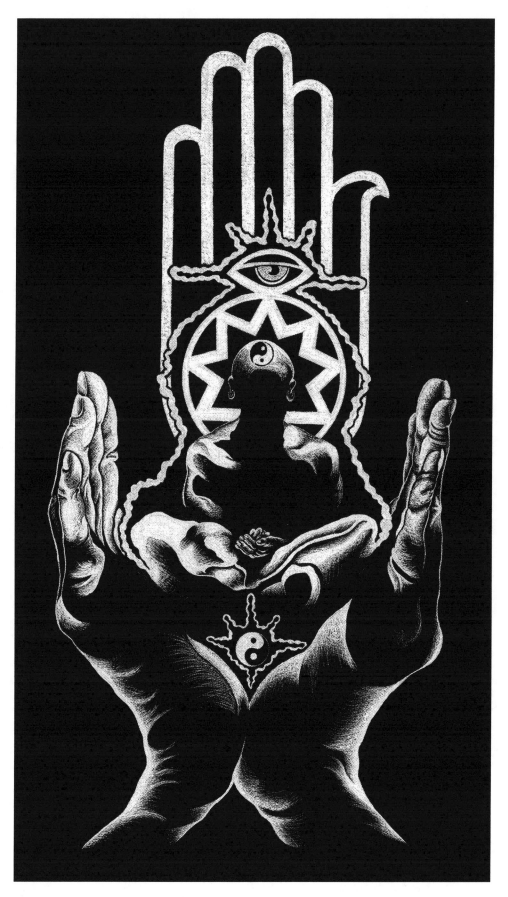

When We Pray 3

Making Special
Signs, Symbols, and the Sacred

From 2014 to 2018 I maintained a small studio-space within a local gallery in downtown Oakland. On the first Friday of each month, the city and most of the local galleries would host an event known as the First Friday Art Murmur. Along with many of the surrounding downtown galleries, my space was open during the Art Murmur, allowing the public to explore galleries and studios of various artists. Despite working full-time for three of the four years I maintained my space; I always did my best to have at least one new piece on display for First Friday. After the first year, this became one of my favorite opportunities to show my work. I welcomed this event because it helped me stay focused during the month, provided me with an opportunity to show my work on a regular basis, and, most importantly, I was able to observe the visitor's' reactions, hear their comments to one another, and speak with them about my work. This direct feedback provided me with insights that have proven invaluable in innumerable ways.

One of the most astounding things about these encounters was how people responded to the symbols used in my work. Those who were not familiar with a symbol found in a certain piece would usually ask me what it meant and why I had chosen to use it. It was always both humbling and inspiring to receive words of appreciation as people began to grasp the connections between the symbol's meaning and the other elements within the piece. It was as if it all began to click, and most would stay and examine the piece more closely as if this newly acquired knowledge allowed them to digest the imagery more thoroughly. Those who recognized many of the symbols would often speak about how much they appreciated their use in appropriate ways, that were not commercial representations or culturally colonizing. These conversations often led to comments about the various nuances conveyed through the symbols encountered within my work. This recognition of a familiar or meaningful symbol often increased their appreciation of the work, filling it with more significant meaning for them. These conversations let me know that I was on target with my desired outcomes resulting from incorporating symbols into my work, and helped me to better grasp the power of symbolism.

The contemporary word "symbol" is a derivation of the Greek word *sunballein* to put or throw together. People tend to use "sign" and "symbol" interchangeably, but the two are quite different. At its most fundamental level, a symbol is a combination of signs. A sign points to something beyond itself.

When you encounter a stop sign along the road, there is nothing inherent within the sign that would lead you to stop. However, since our society has come to a consensus that a red octagon with a white border indicates that you should stop, you do. The sign points you to a concept or activity that is beyond itself. Signs are usually very direct and simple in their meaning which ensures they most often remain one-dimensional. However, symbols carry more depth; they are more complex and multidimensional because they are comprised of signs. At their best, symbols are impregnated with layers of meaning that often overlap and interpenetrate one another. In many cases, this allows for a symbol to contain multiple signs and multiple meanings. This quality allows for various symbols to combine and relay complex conceptualizations in an immediately identifiable form.

Let's take the six-pointed star as an example. Most of us in the Western world would associate this sign with Judaism and, more than likely, think of the Star of David. In the Jewish Kabbalistic writings, this star stands for the interpenetration of body, mind, and spirit. In the Christian context, the star is often viewed as the Star of Bethlehem and is associated with the birth of Christ, and the guiding light as it led the wise men to Bethlehem where they found the infant Jesus. In Sacred Geometry, this star symbolizes the union of the higher and lower selves as they interpenetrate and find balance within the center point. If we examine ancient Goddess cult symbolism, we find an association with sacred sexual energies representing the union of male and female energies as they interpenetrate during sexual union.[1] In all of these instances, there is an overriding emphasis upon union, interpenetration, and the combining of the spiritual with the physical. Any additional meanings are then added based upon the identified cultural context in which the symbol has been encountered. One could place the star around other symbols to create more complex layers of meaning. Despite its simplicity, this symbol is pregnant with meanings that can shift or change within a given cultural context. Culture and context help to create the power and complexity inherent within symbolism

Since all energy carries a frequency, our thoughts are also conveyors of frequency. When we apply this to symbols and signs, we understand why they hold so much potency. Their ability to elicit certain thoughts and the feelings associated with those thoughts can create powerful effects within those who encounter a particular sign or symbol. The very apprehension of a symbol

Damon A. Powell, Ph.D.

generates these thoughts within the mind of the viewer. Symbols have the power to transmit large quantities of information with direct immediacy to those who understand their meanings. This dynamic illuminates the reasons why symbols are placed upon sacred objects, over entryways, and used during meditation practices. For those who encounter a symbol daily or through extended periods of meditation, there is an immense amount of potential energy available for creation and manifestation; such consistent engagement with a symbol can have life-changing results for those who know its meaning. When dealing with symbols, a picture truly is worth a thousand words.

Signs and symbols help us to make things "special." If human beings lacked the desire to make anything "special," we would lead very drab and indistinct lives. This impulse to make things special is as natural to us as eating or breathing; it is one of the most significant aspects of our humanness—particularly for those of us who are striving to live our lives with an intentionally spiritual focus. It is this desire that lies at the heart of any discussion on the distinctions between the sacred and the secular. Things which we have designated as "special" are deemed as such because they hold significant psychological value, individually or collectively.[2] We prize an ideal, experience, object, symbol, person, or role to such a degree that we imbue it with significant psychological value. By doing so, the value we place upon it distinguishes it and, in many cases, it becomes so special that it enters the realm of the sacred. This act of valuation is the true essence of the sacred-secular distinction. Whether individually or collectively, human beings possess an innate need to make things special, and the degree of value we place upon them determines whether they can be deemed sacred. Throughout history, art, signs, and symbols have played a significant role in this process by helping to designate something as "special," remind us that it is "special," or celebrate its particular psychological value.

"Making Special" has been an important part of human evolution, social bonding, and cultural development since our beginnings. It is another form of manifestation that allows us to imbue form with significant value. This value placement can be through artistic expression; the remembering of a significant event; the use of ritual, the creation of a symbol or memorial; or any other practice that allows one to imbue value into form. When we go so far as to designate something as sacred, we have elevated it to the level of the

suprasensuous, The catalyst for these acts of "making special" can be best described as a kind of foregrounding.[3] Most of us live the majority of our lives in a state of waking consciousness. Each of us has what we could consider our normal baseline state of consciousness that helps form our personality and allows us to navigate our way through the routine aspects of daily life. But from time-to-time, events or circumstances occur in our lives which in some way force us into or illicit the breaking through of a higher state of awareness. These circumstances cause a rupture or disruption in what we would consider our baseline state of consciousness and rise to the foreground of our awareness. They are often bursting with significant emotional value, making them even more memorable. As a result, many of these experiences are used by the mind as markers of significant value that become embedded in our consciousness and rise to the foreground as cherished memories. These experiences of foregrounding can be either positive or negative initially and have the potential to transform from one to the other later in life as we recall the memory from our present perspective.

Let's examine the following example: a motorcyclist named Kenya has an accident along a dark back country road. She runs off the road, hits a large patch of gravel, slams into the guardrail, and dies instantly. This event and the memory of it create a significant amount of emotional pain for her family and immediately embed themselves in the foreground of their consciousness. In the years that pass, the family will remember this experience and use it as a mental marker around which to center other events in their lives because it was brought so vividly into the foreground of the family's collective consciousness. When recalling other family events, they may say, "Oh yes, that happened six months after Kenya's accident." The family decides to develop a ritual around this event by going to the accident site each year to pray and place flowers. While at the site, Kenya's mother paints a red heart with a "K" in the middle on the guardrail. On the Christmas following Kenya's death, her mother has an ornament containing the drawing custom-made and gives one to each member of the family during the holiday season. Kenya's partner saved a piece of the motorcycle debris and keeps it on her home altar. Upon hearing the news of Kenya's death, Kenya's sister went into a deep depression and began her journey on to a more spiritual path, crediting prayer and meditation as the spiritual tools that helped her to move past her sister's death and turn her life around for the better.

Damon A. Powell, Ph.D.

In this example, we find that:

1. The date of the event is now used as a family life-marker.
2. By visiting the gravesite each year the family has now created a ritual that gives this life-marker an added dimension of significance, increasing its psychological value.
3. Kenya's mother creates a symbol to mark the event and the entire family imbues it with even more significant value as they receive the ornaments.
4. Kenya's sister eventually transforms the negative emotional value of the event into more positive energy because she begins to view it as a symbolic reminder of her journey of transformation.
5. Not only has the site of the accident been "made special" by the family, but Kenya's partner has elevated the piece of motorcycle debris to the level of the sacred as it sits on her altar. Kenya's mother has also done this through the creation of the ornament.

In other words, Kenya's death creates a significant foregrounding event which is then "made special" by her loved ones in various ways that help to reinforce the significance of this foregrounding experience. The event was "made special" through the use of ritual (gathering before the sight) repetition (annual activity); the creation of icons (ornaments and collecting debris); and timeline imprinting (being used as a time marker in the family history).

The act of "making special" can occur as the result of both positive and negative life experiences. In the case of Kenya's sister, the event now carries both positive and negative psychological value. On the positive side, Kenya's death also functions as a sign in her sister's life. We defined a sign as something that points to or beyond itself. In this instance, the recollection of Kenya's death points her sister *to* the healing and transformative role of Spirit and power to help her reshape her life; it points her toward continued spiritual connection and practice. The foregrounded event now acts as a positive sign in Kenya's sister's life. The power of foregrounding and the acts of "making special" that accompany it can occur in both positive and negative life events. However, knowing that some negative events have the capacity to be imbued with more positive psychological value provides hope and a sense of agency. We can look for signs that point toward more positive and, therefore, higher frequency points of foregrounding that will allow us to disassociate at

least some portion of the negative charges associated with a negative, low-frequency event. Imbuing positive psychological value is much more than mere positive thinking or looking for the silver lining. We are literally making a conscious effort to shift our energetic frequency and intentionally foreground other aspects of an experience that we can then "make special." We do so by either attaching them to the negative event—thereby dulling some of its charge—or using the positive insights as filters through which we understand or interpret the lower frequency event, as in the case of Kenya's sister. The use of this ability is an often-untapped aspect of conscious creation.

From a mystical perspective, the recognition of signs plays an integral role in healthy spirituality and its development. Most sacred theological texts of any tradition are filled with treatises on the recognition and interpretation of signs, which play an essential role in the spiritual life because they are essential to the act of discernment. The Christian Bible, the Bhagavad Gita, and many other sacred texts have been chocked full of interpreted signs, events as signs, specific numbers as signs, divination tools that provide signs, etc. If you follow any contemporary persons who channel or those who work with tarot cards, numerology, or astrology, you will find that they too are concerned with signs. Individually, we pray for signs; we look for signs along our path; we interpret events in our lives as signs, and so on. For those of us who are seeking to live a consciously spiritual life, the discernment of signs is an indispensable tool for interpreting the will of Spirit. Spirit attempts to guide and support us along the path through the use of signs. Developing and honing our ability to recognize, listen for, feel, and understand these signs is essential to our spiritual growth.

The art and practice of discernment is never-ending. There is always more to absorb, comprehend, recognize, and embody—if we are to remain at this level of vibration. If we truly want to experience connection and feel that we are connecting and living in Spirit, then we must work diligently at the recognition and discernment of the signs that Spirit, our guides, the angels, and the universe present to us. To practice this kind of discernment is also a commitment to learning to trust our intuition. Spirit is constantly speaking, and its vibrations never cease—but are we tuned in to receive them? The signs are always there, and it is within them that we move, breathe, and live out our very being. The development of the skill to receive them is, in fact, a very a large portion of our spiritual practice. Developing our ability to recognize and act upon the flow of information swirling all around us helps us to place greater

trust in our intuition and the divine guidance that is available to us at any given moment. It is this recognition that opened my spiritual eyes up to a whole new vista of insights. Making this simple but profound shift in perspective filled me with a greater capacity to trust my intuition and begin paying closer attention to the events in my life. By consciously paying attention to what came to my attention, I was much more easily able to discern what people and actions would point me toward the next steps along my path. In meditation practice, this is often referred to as being the "noticer of what you notice," or simply recognizing what comes to the foreground of your experience at any given moment. As you develop this practice in your meditation, it should become easier to utilize it in other situations. Doing so allows you to begin distinguishing which things you notice are being "made special" from those that are primarily ego-based thoughts and remembrances that float to the surface of your consciousness.

What was coming more immediately to the foreground of my consciousness? What did I need to "make special" and why? Asking these kinds of questions increased my trust in Spirit and deepened my meditation practice, as it helped me to see how important it was to practice looking for the signs instead of wondering and waiting for what was often already right in front of me.

So, look for the signs. Open your senses and feelings to the signs. Pray for a sign. Meditate on the signs. Believe you have and will continue to receive the right signs. Give thanks for the signs. Trust the signs. You'll have more appreciation for the journey if you pay attention to the signs along the way.

1 Gaia Mind, http://www.gaiamind.com/m-star.html. (accessed on August 25, 2018).

2 Ellen Dissanayake, Homo Aestheticus: Where Art Comes from and Why, (Seattle: University of Washington Press), 54.

3 Alejandro Garcia-Rivera, The Community of the Beautiful: A Theological Aesthetics (Minnesota: Liturgical Press, 1999), 170.

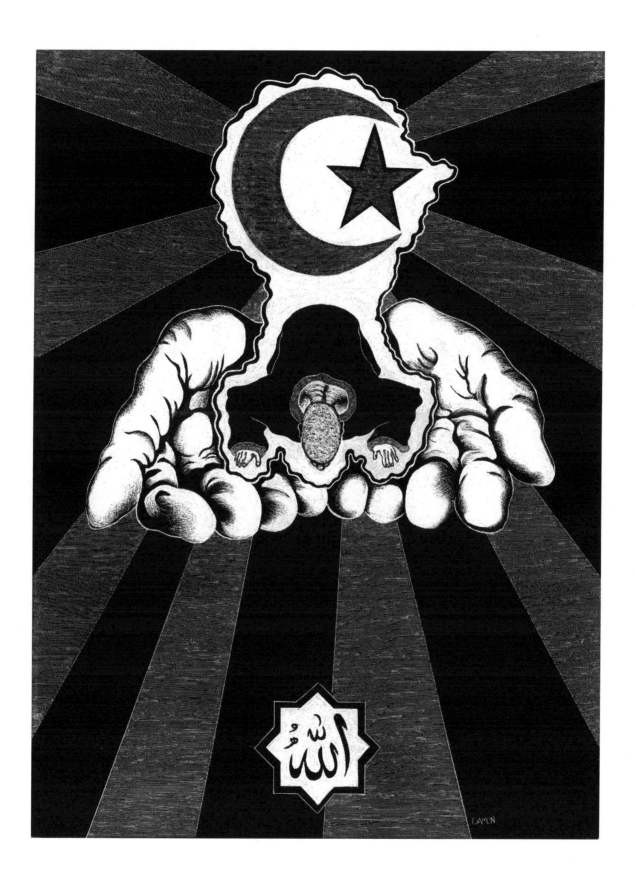

29

When We Pray 4

The Work Is All Divine:
The role of Imagination in Prayer and Manifestation

When I was a young man attending seminary, there was an instructor named Bishop Hildebrand whom everyone knew and loved. I had heard many tales about him and his teaching style weeks before the semester had begun, and I was eager to sign-up for one of his classes. Unfortunately, it was announced shortly before the outset of the semester that the Bishop would be retiring from teaching and all his scheduled classes were also canceled. However, I did get an opportunity to meet Bishop Hildebrand briefly in the halls of the seminary as a more senior student and I were heading toward our afternoon class.

The student saw him at the end of the hall and enthusiastically called out his name, "Bishop Hildebrand!" The professor turned around slowly, and his countenance immediately lit up the entire hallway. As we approached him, the energy and sincerity I felt emanating from this man made it easy to understand why he was esteemed in such high regard. The other student introduced us, and as we shook hands, I could feel the warmth and genuine concern he expressed as he inquired about my current classes. Hearing his words of encouragement and being in his presence for those brief moments made a very strong impression upon me that has lasted to this day. As we took our leave and headed into class, the senior student turned, raised his arm, and exclaimed, "The work is all divine!" The Bishop gave a sly grin, waved his arm and repeated, "The work is all divine, young men! Never forget it!"

At the time I had no idea that this was something the Bishop repeated to his students at some portion of every class for all the years he was teaching there. "The work is all divine." This simple phrase rang out in the halls and study groups throughout my entire time in seminary and I have never forgotten it. I had no idea how significant that phrase would become at various points in my life. Its depth has become more apparent with each passing year. Through life's joys and sorrows, in the midst of hectic meetings, or the quiet moments found among simple shared pleasures, I've been reminded that, "The work is all divine!"

Keeping this phrase in mind, let's shift gears to discuss imagination. Before we can begin to examine the role imagination plays in the practice of prayer and manifestation, it is imperative that we take a little time to understand what imagination is and how it works. The word "imagination" has its roots in the ancient world; the Hebrew people used terms like "*yester*," "*sheriruth*," or "*machashebeth*," while the Greeks spoke of "*dialigismos*," "*dianoia*", and

"*logismos*." All these terms have variations in meaning; they can be roughly summarized as shaping, forming, re-forming, thought, impulse, and inclination. One of the most interesting things about these words is that they all imply action (shaping or forming) or point us toward the potential for action (impulse or inclination). Viewing imagination as an action is a very different way of thinking about it than we are accustomed to in our everyday lives. When the words imagination or imagining come up in conversation, we often think of them in very static terms—imagination as a motionless, internal process undergone in complete isolation. But this is quite far from the truth.

The act of imagining implies shape or form and is often directed toward something or someone. When we are imagining, we are engaged in the process of shaping or forming some "thing" in a very specific way.[1] The group of beings known as Abraham and many modern spiritual teachers often point out that in the process of manifestation, we must never forget that our thoughts are "things." Our thoughts possess an energetic reality that is just as real as any other material "thing." You may be familiar with an experiment that asked Buddhist monks to pray or meditate upon vials of water while thinking or imagining a specific concept or emotion. In every case, the water was shaped and formed into various patterns identified on the subatomic and quantum levels. The act of imagining a particular concept or feeling had a direct effect upon the water contained in the jars. What appeared to be inaction was actually an act of creation and formation through the use of vibration. The same holds for imagination. Imagining is a form of action that possesses vibrations that are directed just as our thoughts are. Imagining, like thought, is an alive and active process that can be entered just like contemplation, meditation, or visualization.

Far too many of us view imagining or the use of the imagination as a frivolous activity lacking any real purpose or value. When we speak about imagining, we often think of daydreaming—which is one form of imagining—or the playful activities of children who have imaginary friends. If you are a churchgoer or religious practitioner, you likely know that the minister often asks the congregation to "use their spiritual imaginations" as she develops a subject or teaching illustration. In the spiritual community, you rarely find a thought leader who will not at some point ask the community to use their imaginations during a meditation, activation, visualization or some other activity. These are precisely the points when I have seen skeptics denounce

the whole experience, or watched many of those present begin to turn off and tune out. My point is that imagination is not always recognized as a cognitive faculty in its own right. Just like other mental faculties, it carries vibration that is directed and shaped. To make effective use of this powerful activity, we must begin to take the use of imagination and its role in the spiritual life much more seriously.

Now that we have established a place for imagination in the spiritual life, it's important that we understand how it works. From a scientific perspective, the use of imagination is believed to involve two basic forms of thought: 1) Janusian thought (the ability to conceive of two or more opposite or corresponding ideas at once), and 2) Homospatial thinking (the ability to actively conceive of two or more things occupying the same space). Psychologists believe that when we engage our imaginations, we utilize these two kinds of thought in order to combine ideas or concepts that were not previously related to one another, creating or expanding them into a larger whole. The entire process is referred to as bisociative thinking.[2] When imagining, we begin to weave together the threads that form our being. These threads often come from images, feelings, subconscious desires, stories we have heard, or spiritual experiences coming together to form an intricately woven tapestry.

When examining these threads, we see the use of imagination as an active, living process. At its best, it is used as a form of creative reflection that allows us to entertain certain ideas or possible outcomes and play out the possibilities that might arise as a result. In this way, we can hypothetically play out the results of a decision or activity to help us formulate a plan, reason through a problem, or create new and better solutions.[3] From a spiritual perspective, the use of imagination gives us the freedom to move beyond the threads that comprise our life experiences and expand them into a much broader way of being. If thoughts are "things" and imagination is an active, living process, then imagining must also be considered an act of manifestation. Imagining is creating! Creating is a manifestation, and manifestation requires creation because all acts of manifestation require form. In the physical world, form is a mandatory requirement for any act of creation or manifestation; whether it be thinking, imagining, creating a work of art, or conducting experiments. At the level of vibration we occupy, everything requires physical form.

If we look again at our definition of imagination and reflect upon the root words that have been used to describe it (to shape, form, re-form), we find

that the use of imagination is a process of formation. Janusian thought and homospatial thinking are just various forms of formation—and manifestation necessitates form. When we pray, meditate or visualize we are giving form to our desires and experiences. During meditation or prayer, have you ever expressed a desire or imagined a particular outcome? If so, you gave your desires form. Ever feel your vibration rising during energy work or meditation and then imagined yourself holding that level of vibration throughout the day? You just gave your desire form. Imagination is the bridge that gives form to manifestation. This form can be created as thoughts, impulses, shapes, sounds, or in any manner that this dimension will permit. It is this quality that makes imagination an integral component of prayer and the spiritual life.

If imagination gives form to thought, then imagination must also precede thought. Daydreaming is a perfect example of this idea. Daydreaming is different from thinking. When we daydream, we are not simply lost in thought because we are not thinking. We are not pondering any specific idea or subject but are instead caught up in the scene that is occurring within. When someone interrupts us in the middle of a daydream, we are forced to compose ourselves and remember what it was we were daydreaming about in the first place. Why? Because imagination is all about image. The root form of "imagination" is "image," and image is about seeing, not thinking. Human beings are primarily image-oriented beings. That's why our eyes are placed directly in the front of in our heads and not on the sides as they are with most other animals. From a cognitive standpoint, we find that most of our forms of communication are also sight-oriented. Almost all forms of language and even a great deal of music brings us back to images. Language is most effective when it describes imagery. That's why the best writers and speakers make good use of metaphors, similes, and other techniques that help the reader to create a visual image of the scene or subject matter they are seeking to portray. Scientists make use of diagrams, charts, 3D modeling, and computer-generated visuals that record in real time. All of this happens because images are primary, meaning imagery precedes thought.

Sight and image are the primary focal point of human perception, just as imagination is the focal point of manifestation. The creative power of Spirit, the vortex, God, or whatever else it might be referred to as speaks to and through us in the imaginative process of manifestation.[4] The reality we experience could never be manifested if we had never imagined it both individually and

collectively. Every aspect of human knowledge and existence owes its life to the imagination. It is our ability to imagine that acts as the ground of thought and provides us with the ability to shape and form our reality according to our desires. Our capacity to create our desires is the reason why so many spiritual teachers place such a heavy emphasis on learning to monitor our thoughts and feelings—because the things we imagine enter our thoughts, affect our feelings, and will eventually be manifested. If we are constantly imagining, then it is in our best interest to work at becoming increasingly more conscious creators.

Prayer, meditation, learning to trust our intuitions, and other spiritual practices are the tools that help us to better harness our awareness. They help us learn to connect to Spirit more consciously while also helping us to monitor the quality and content of our thoughts and perceptions. The quality and content of our perceptions is a primary concern if we keep in mind that everything we imagine or think will eventually manifest in one form or another. For instance, what if you were hiking along a very high mountain trail and your foot slipped near the edge of the trail? You could very easily feel as if you might fall off the precipice. But what if you caught yourself and recovered? Then, while standing in the spot where your foot slipped, you looked over the location only to realize that you weren't nearly as close as it seemed. There was no real danger of ever going over the edge. However, in those moments, you not only felt you might go over the edge, but you also imagined yourself possibly falling off the precipice. Even though the belief you held at that moment was false, the power of your imagination was still active and manifested itself in feelings of fear or panic. Physiologically, your body responded on the molecular and cellular levels by increasing your heart rate and adrenaline levels. Even though the belief that you were falling was found to be false, the link between feeling and imagining still produced some form of manifestation. Whether you were sitting alone in your room and imagining that the events happened, or they happened while you were out on a trail hiking, the power of imagination would still be active.[5] In the latter case, the manifestation was created consciously because you were actively imagining it, whereas it was created unconsciously in the former. If we are constantly undergoing the work of imagining and manifesting, it would be in our best interest to work at refining our ability to control the quality and content of those manifestations.

In the Christian tradition, humanity is created in the image of the divine. This concept is referred to as the *"Imago Dei,"* or the "Image of God." One of the key sources for this claim is within the book of Genesis, the opening book of the bible, which states, "Let us make humankind in our own image, according to our likeness…".[6] Most religious scholars and theologians rest this claim upon lengthy discussions about the potential for humans to exhibit truth, goodness, and intelligence. If we examine the text closely, we find that the most important words in the sentence are "make" (manifest) and "likeness" (image). The overriding focus of the conversation hinges upon God having imagined the manifestation of beings who would be in the divine image. The primary faculty of this likeness rests in three areas: the ability to perceive (sight); the ability to manifest; and the ability to imagine. It is imaginative power that holds the potential for the perception and shaping of form in the spiritual realm and its birthing into the physical world.

Prayer, meditation and visualization are acts that not only help us to monitor our thoughts and imaginings but also open the door to greater depths of perception and awareness. The feelings and perceptions one can tap into using these spiritual disciplines are of a much sharper and more distinct quality than our normal state of daily awareness. They help us move beyond the boundaries of "self" and bring us into greater contact with the higher levels of vibration that exist beyond this dimension. Throughout human history, it has been this level of perception that has allowed creative and spiritual figures to arrive at deeper truths much more quickly than those who spend a great deal of time searching for answers through logical and rational modes of reasoning.[7]

The masses of our modern world have only recently begun to accept that insights gained through intuition, channeling, and other forms of perception are valid. Even science has begun to research these phenomena and provide empirical data to support them. Throughout the world, more and more people are being exposed to the increasing validity given these insights through TED Talks, YouTube channel discussions, and mainstream media articles that have catapulted scientists or religious figures like the Dalai Lama into the limelight. When we consciously choose to manifest from this level of perception we are truly acting in the image and likeness of God. Then, our work is truly all divine.

Without imagination, there would be no hope of even knowing or conceptualizing the spiritual because it would be completely beyond our

Damon A. Powell, Ph.D.

powers of perception. Most people would agree that the spiritual insights human beings can now glean are still partial and ever-evolving. Without the power of imagining, the spiritual insights we have acquired over the centuries would not have been possible. It is insight that places imaginative power at the mid-point between the higher dimensions of Spirit and the lower vibrations of matter. Imagination serves as both converter and still-point. It occupies that central place—the gap between dimensions, or what some have referred to as "the eye of the wormhole." Our spiritual practices allow us to tap into that stillness, thereby entering sacred space. From that point, we can see into what is beyond, tap into the vortex, and then consciously begin the work of shaping and forming those insights through acts of imagination and manifestation. In a sense, one could say that we are beholding the divine as we manifest in the physical world. We see and then manifest from that place of vision. The work is all divine!

Another helpful approach is to think of imagination as the tree-top level.[8] In many parts of the jungle, the foliage is so plentiful and the trees so vast that they block out most of the sky, casting everything below them in kind of dull light. However, there will always be instances when you catch a break in the foliage and can stand in a stream of light that has reached the jungle floor. In some of these instances, one can even see the heavens in the sky above the trees, but those instances are few and far between.

Unfortunately, what I have just described can also describe the fabric of everyday life for many of us. We travel through life living a kind of dull shadowy existence that on random occasions bathes us in the light of joy, happiness, and spiritual insight. But what would happen if we climbed up into the tree-tops? We could occupy a position where we would have access to both the sun and sky while still being able to interact and observe what was happening on the jungle floor below us. From the trees, we could access the higher realms of the sky or climb back down to the jungle floor whenever we wished to do so. The tree tops are the realm of imagination, the position from which we behold and then make. Prayer and other spiritual practices are the climbing gear that we acquire to ascend the into the tree tops. The tree tops are the holy, sacred places from which we engage in the divine work of manifestation. The work is all divine!

The group of beings channeled by the medium Sheila Gillette (referred to as THEO) tell us that time is perceptual. Time as perception is often confirmed

through practices like prayer, meditation, and creative practices in the arts. The popularity of this notion has also gained credibility in popular culture due to the way racers and other athletes describe their experiences while engaged in their craft. This heightened sense of perception allows us to perceive time as existence. In this state, our perception broadens and our sense of time as flow becomes expanded until we begin to perceive time as we exist in the here and now. Philosophers and artists have referred to this experience as "creative ecstasy," while sports figures often speak of "the zone"— a state in which time appears to slow down due to having entered a heightened state of awareness.[9] The slowing of time is one of the byproducts of operating from tree-top level. In the tree tops, we are lifted. The images that form in our imagination in the tree tops are an affirmation of the image of God within us, and the manifestations flowing from that space are a form of praise in their own right.

1 John McIntyre, Faith, Theology and the Imagination (Edinburgh: Hansel Press, 1987), 5.

2 . William Dyrness, "Christian Imagination" Image 15 (Fall 1996), 91. Dyrness is expounding upon the work of Dr. Albert Rothenberg.

3 Amy Mullin, "Moral Defects, Aesthetic Defects, and the Imagination" The Journal of Aesthetics Art and Criticism 62, no. 3 (Summer 2004), 249-250.

4 Robert J Barth S.J., "The Theological Foundations of Coleridge on the Imagination" in Symbolic Imagination, 2nd ed, (Fordham: Fordham University Press, 2001), 18.

5 Shaun Nichols, "Imagining and Believing: The Promise of a Single Code" The Journal of Aesthetics and Art Criticism 62,:no. 2 (Spring 2004), 130. There are clear cases in which imaging and believing bring about differing responses, but I am currently concerned with pointing out the convergences in order to establish a connection.

6 Genesis 1:26 (New Revised Standard Version).

7 Earle J. Coleman, Creativity and Spirituality: Bonds Between Art and Religion (Albany: State University of New York Press, 1998), 66.

8 Alejandro Garcia-Rivera, The Community of the Beautiful: A Theological Aesthetics (Minnesota: Liturgical Press, 1999), 185.

9 Nicolas Berdyaev, The Beginning and The End (New York: Harper and Brothers Books, 1957), 177.

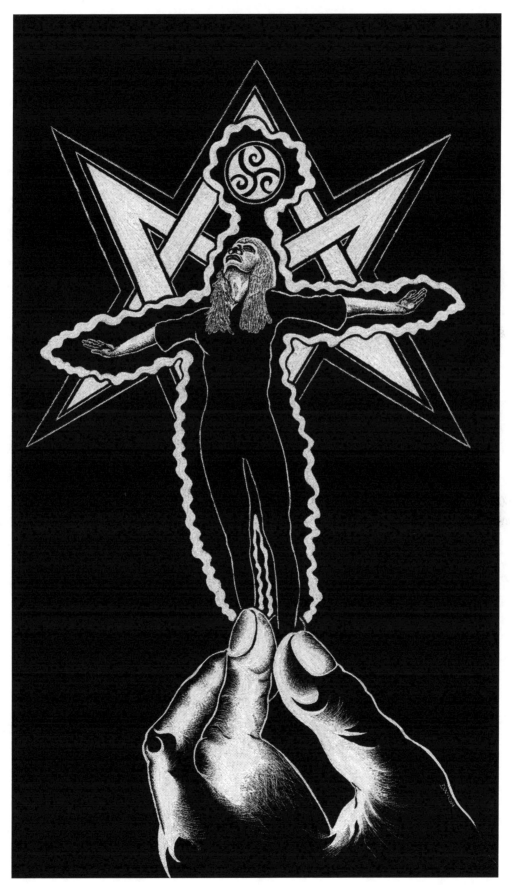

When We Pray 5

Awakening
The Art of Prayer and the Art of Life

Awakening : The Art of Prayer and Art of Life

Anyone who has chosen to live their lives from a more spiritually tuned perspective has at some point experienced some form of awakening. For some it was a slow, expansive burning, similar to the heating of hot coals on a barbecue grill; for others, there was a sudden—almost instantaneous—ignition of our inner spiritual centers, more akin to the arc of flame one experiences when lighting gasoline. In either case, the fire began to burn, and the insights came. According to the Catholic tradition, Saint Ignatius of Loyola referred to this experience as an awakening of the spiritual senses. When these senses are awakened, one can thirst for the divine, taste the truth found in spiritual literature, feel the presence of Spirit within and around you, and see the divine hand orchestrating life events. No matter what the metaphor, the commonality is that some present but predominantly dormant thing within was awakened. Once these senses have activated, they can be muted but never permanently deactivated. The door has opened, and we have stepped across the threshold into the realms of the suprasensuous. We call this awakening.

No matter what your spiritual beliefs or religious tradition, some form of prayer is the common denominator. Prayer is the bedrock upon which the spiritual life rests. Whether it be formal, ritual, personal, or corporate, the emphasis upon prayer for spiritual growth and development is universal. There are innumerable ways to pray, and I use the word as an umbrella term to cover all its many expressions. In its most universal application, I am referring to prayer as the movement of the inner being toward the divine. This movement can occur through a variety of means such as meditation, movement, mindfulness practices, chanting, connecting to nature, creative ecstasy, contemplation, or any other practice that touch one's being in a manner that uplifts and connects it more deeply to the divine. The act of prayer is the yearning of the heart to become more intentionally present to the divine. The form of this yearning is of little importance. Whether it expresses itself in the form of a desire for aid, an expansion of consciousness, a basking in the stillness of all that is, or an expression of gratitude, its most significant aspect lies in its authenticity and intention.

Those who misunderstand prayer have often accused those of us who regularly practice it of being escapists and otherworldly, but this is quite distant from the truth. Prayer is not an attempt to escape our current reality but rather an attempt to embody it more fully. By going within and seeking to consciously

connect with the universal, we begin to understand that we can only do so by experiencing that connection at our current level of vibration. In other words, we must experience the suprasensuous by embedding it more fully within the sensuous. Therefore, I find the spiritual senses metaphor very appropriate. We embody the universal within the particular by allowing it to communicate with us the only way it can—through our senses. Since aesthetic experience is about sensuous perception and prayer is a method for channeling and communicating these perceptions, the act of prayer can be considered a mode of aesthetic embodiment; it is an aesthetic modality that helps us to perceive and receive suprasensuous input in a manner that allows it to be embodied within us. I say embodied because the information we receive becomes progressively encoded within our cellular matrix, just as it is with any other physical perceptions. You may recall feeling a sense of exhilaration or a rise in your vibration that gave you a feeling of expansiveness; feelings of inner peace; time slowing down; and sensory perceptions heightening, lifting emotionally and physically. In the theological realm, we refer to this uplifting as anagogy. Many artists speak of encountering these feelings when they are engaged in the act of creation.

Artistic expression is also considered an aesthetic modality because of this same capacity for embodiment and uplift. Many of us who have encountered a sense of connection to the divine have developed this connection from experiences we have had with artistic expression. For this meditation, I will refer to all forms of artistic expression as "art" in order to emphasize the connection to both aesthetic experience and spirituality. Art, like prayer, is an essential component of all forms of spirituality and religious experience. I separate the spiritual from the religious to make the distinction between a more open intuitive, unstructured approach toward spirituality and the organized sets of practices, beliefs, and rituals that make up religious communities. Religious experience can be spiritual and contain spirituality; likewise, some forms of spirituality also incorporate ritual when practiced in a corporate setting. However, both utilize various forms of the arts as a means of communicating these expressions. The modern and postmodern art worlds have managed to remove the religious or any spiritual expressions from critical discussions about art, but the opposite can never be the case.

If you visit a contemporary museum or local gallery, you're likely to find that there is no mention of the spiritual or religious aspects of an artwork's creation or of spiritual insights about the work by critics or gallerists. The very process

of cataloging and displaying the work often serves to disconnect it from its cultural meanings or suprasensuous orientation. Docents are particularly good at shying away from these kinds of discussions in their tours, even if spirituality or religious affiliation played prominent positions in the life of the artist. Omissions of this kind become particularly evident when dealing with ancient artifacts or crafts created by less complex societies. But most of these items were created for ritual use or in the context of a more spiritually oriented community. These works are often presented in some of the most sanitized contexts, devoid of any connection to the settings and circumstances under which they were more than likely created. This sanitization leaves no room for discussions about the religious, mystical, or spiritual aspects of the art's creation or effect upon the viewer.[1] In many cases, this aspect of the work has played an integral role in both creation and interpretation.

However, the arts play an integral role in all forms of communication related to spirituality because they act as vehicles for the expression of the suprasensuous. When we do encounter the divine or have a heightened spiritual experience, some form of artistic expression is often utilized to communicate it. If you wrote or spoke about it, you would likely end up using metaphors or similes. If you wanted to depict it visually, you might draw, paint, or sculpt an image. If sounds were involved, you could write a piece of music or make sounds to share what you heard. The arts are the only vehicle with the capacity to express the feelings of anagogy that accompany suprasensuous experience. The arts can uplift and translate suprasensuous experience into identifiable sensory data by helping us to express emotions and feelings in ways that are nondestructive and often cathartic. The arts allow us to communicate joy, fear, ecstasy, beauty, and the transcendent in ways that are relatable to others while being simultaneously embodied in physical form. Not only does the creation of art provide us with a means of expression that is cathartic, but it can also bring a great deal of psychological pleasure to its creator and those who encounter their creations. Creative works of artistic expression manifest these feelings into physical form. These transmissions are not always exact or one-to-one, but they are the closest methods of correspondence we have for the conveyance of spiritual truths.

The arts are a vehicle for the communication of spiritual truth in a way that allows them to be easily grasped and experienced. They mediate between the visible and invisible by helping to transmit and invoke feelings that cannot be

expressed using logical, deductive reasoning. In many cases, these emotions and perceptions are shared communally among all viewers of a given work. Artistic expression can converge, coordinate, and attune individuals and groups to one another. By doing so, it helps to create feelings of connection and promote social bonding. Historically and culturally, we find that people have used the arts as a point of convergence that allowed them to share the same stories, see similar imagery, share mutual feelings, and transmit both cultural symbols and spiritual values.[2] The process of transmission happens because we are often lifted (anagogy) during the experience. At its best, artistic expression lifts us to a higher level of vibration that then allows us to more fully grasp the inner depth of the expression. Both the arts and prayer share this capacity to lift us and take us beyond our normal level of sensory perception.

Since science has proven that all of creation is vibration and frequency, my statements regarding the capacities of the arts and vibrational embodiment are becoming much more mainstream. In neuroscientific terms, this can be summed up in the concept of resonance. If you frequently attend plays, dance performances, music recitals, poetry readings, or other artistic performances, you may have noticed the following components: designated space, ambiance, "making special," embodiment, and resonance. Let's use a play as an example. Plays are most often put on in a designated space in which the activity is to take place, such as a theater or amphitheater. The staff, the lighting, the props, and music are all geared toward creating an ambiance that complements the performance. Just before the performance starts, the lights may dim; an announcer might enter the stage or speak through a microphone, setting the stage for the performance and letting you know that what you are about to encounter is special or somehow different from an ordinary experience. Then, the event begins and the performers engage in the performance. During the performance, the actors and the viewers will co-create a field of resonance in which both groups' brainwaves will sync with one another. The syncing process is what allows you to feel the shock the heroine feels or sense the looming danger as the plot thickens; this is all possible because the group's brainwaves have synced, thereby creating an energetic field which encompasses the area in a feedback loop. This field of resonance not only enhances the emotions and perceptions but also enhances mutuality as both the performers and the viewers have the power to affect and to be affected by one another. Everything that happens up to the moment the performance begins has been intuitively scripted to prepare and

aid the viewer in more easily creating a resonance field. This process exemplifies the inherent power of the arts and their ability to create resonance.

The term "art" is also used to describe a person who has acquired a high level of technical skill in a particular activity, or an activity that requires a specific set of technical skills in order to be used effectively.[3] It is this use of the term that is often used in conversation when someone has been acting skillfully in a given area. We speak of people mastering the art of war, the art of conversation, or the art of negotiation. This definition is a good starting point, but it fails to acknowledge an especially important aspect of what it means to speak of art in this manner; the missing factors are excellence and uplift. When we speak of something being art in this manner, another essential component is the implicit acknowledgment of excellence. The quality of the manifestation must be extremely high to be spoken of in this way. When we say that someone has "mastered the art of conversation," we are acknowledging that their level of knowledge and skill is of exceptionally high quality. So much so, that they have taken something that can often be considered commonplace or mundane and elevated it to a level that uplifts and inspires us; they have achieved a truly exceptional level of mastery that is a thing of beauty to experience. What seems difficult or elusive for others appears to be almost effortless on the part of someone whose manifestation in a given area has become so fully embodied. This embodiment then gives rise to the recognition of artistry. When we encounter this kind of artistry, we are lifted, inspired, and even awed by the experience; it becomes truly beautiful to behold.

Those who strive to move along the path of enlightenment intentionally and mindfully begin to gradually embody their experiences within themselves. If prayer is the movement of the heart towards the divine, and the arts provide us with a vehicle for expressing these movements, we embody the art of living, as our living becomes progressively more immersed in these two ways of being. The act of transmitting these experiences with Spirit springs forth as a natural part of authentic daily living. There is no need to shout, convert, or proselytize to others because the act of creation has become actively embodied within us. Our bodies and our energy are constantly transmitting, constantly connected whether we are aware of this activity or not. When we do so with intentionality, openness, and authenticity, others can feel it in our presence. This way of being lies at the heart of conscious creation and elevates our living to the level of artistry. There is no need to become an artist formally; life is prayer is art. The art of prayer gradually becomes the art of life as we gradually progress

toward deeper levels of embodiment and mastery. As we practice becoming more conscious creators through prayer, the quality of our creations becomes increasingly more beautiful. As we embody more of the suprasensuous and express it within the context of everyday life, our lives become more beautiful manifestations of artistry, moving us along the path of enlightenment.

As our living becomes a form of artistry, we are better able to understand what it means to live an awakened life—to be mindful and present to such a degree that our living becomes a form conscious of prayer in and of itself. As we become more adept in our practice of awakening, the expressions of that practice also become increasingly more effortless and evident. We innately begin to *be* far more than we can say, and this being has a way of creating fields of resonance with others in ways of which we are completely unaware. Some of us have had the experience of sensing incoherence within those we encounter, even if simply by asking a friend, "How have you been?" only to feel the discontinuity between their energy and their professions that, "Everything is just fine!" Despite what we saw and heard, we sensed the discontinuity and felt the energetic incoherence radiating silently from their being. As the art of prayer increasingly melds into the art of life, we become more resonant with others because our energetic field develops a more consistent level of coherence recognized by others as authenticity. We awaken to a much richer world of perception that enriches every aspect of life. This enrichment then becomes embodied to such a degree that we truly understand what it means to live the life of a human *being*.

Awakening is not a movement away from or above our humanity; it is a progression that places us on a path toward more fully becoming the human beings we were created to be. Awakening moves us more deeply and richly into ourselves within the context of our humanity. Prayer helps us to make this movement while the arts allow us to express it within the context of daily life. As a result of this process, we become more able to authentically *be* human.

1 Paul Crowther, "Defining Art, Defending the Canon, Contesting Culture" British Journal of Aesthetics, vol. 44, no. 4 (October 2004), 371.

2 Noel Carrol. "Art and Human Nature" The Journal of Aesthetics and Art Criticism 62, no. 2 (Spring 2004), 100.

3 Oxford University Press, "Art" in the Oxford English Living Dictionary (online). https://en.oxforddictionaries.com/definition/art. (accessed 8.20.2018).

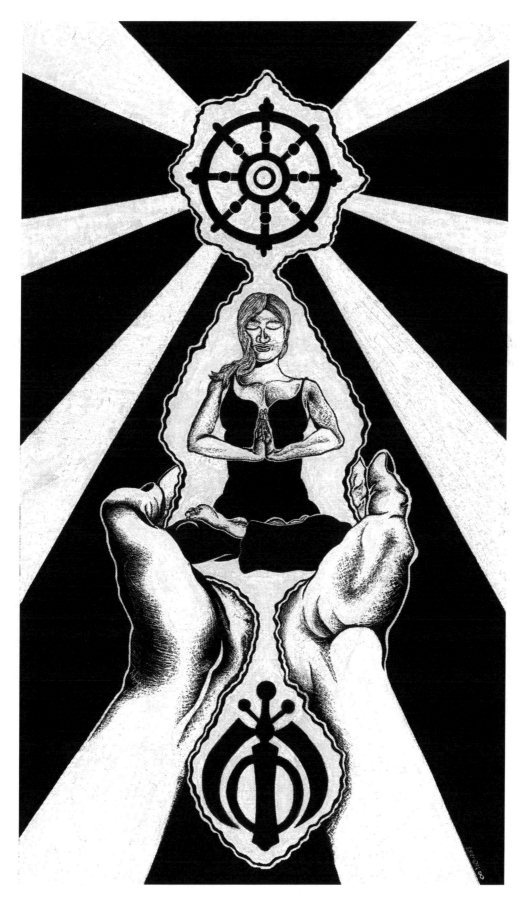

47

When We Pray 6

In Defense of the "Woo-Woo"
The Aesthetics of Mysticism and the Spiritual Life

It happened again yesterday! I rushed to the studio hoping to get there by noon so that I could settle in before tuning in to a special podcast I was extremely eager to hear, featuring a well-respected intuitive I had the pleasure of hearing a couple months earlier. I was looking forward to gaining additional insights. I pulled up the podcast website, plugged my speaker cable into the laptop, adjusted the volume, and sat the laptop on the light-table on the left near my art table. Sometimes, listening to a spiritual podcast while I'm working helps me stay focused on the work while remaining more spiritually open. I consider my work a form of intentional channeling and find things flow more smoothly when I can maintain a higher vibration. I still had a few minutes before the podcast began, so I took a seat at the small altar I maintained in the studio and completed a four- to six-minute mini-meditation. Afterward, I uncovered the unfinished piece that was sitting on my art table, settled myself into my artist's chair, clicked the "play" button on my laptop screen, and got ready to work.

For approximately 45 minutes, everything was going fabulously well. I was making good progress on my piece, and the work was flowing. I was feeling settled and connected. The show host was connecting with the speaker and asking very pertinent questions. The speaker was on point and had just completed a powerful channeling session. Then it all fell apart. The host was in the process of closing out the show and began to undermine the whole podcast by going into a lengthy apologetic tirade aimed at anyone who had been offended or disturbed by some portions of the session getting a little too "woo-woo." "Woo-woo," I thought to myself. "Why in the hell was this considered 'woo-woo'?" I lost it. I lost my focus, my connection, and noticed an all-to-familiar mixture of disappointment and anger welling up within me. It was the fourth or fifth time I had heard these kinds of references in the last few months, and it was beginning to bother me. I sat my scratching knife down, closed my eyes, and began to breathe deeply.

The current state of what we describe as popular spirituality or contemporary spirituality (new age, self-help, metaphysical studies) is slowly but surely pushing out many of the conceptual frameworks that have traditionally under-girded them. This push represents a shift away from more traditional paradigms that relied heavily upon mysticism, religious affiliation, aesthetic formation, mystery, and—in some cases—secret societies of knowledge. The results of this shift provide evidence of the increasing separation of these concepts and

practices from the socio-cultural and psycho-spiritual contexts that played a significant role in their meaning and creation, as well as their effects on those who practiced them. An example of this is found in the rise of yoga in the realm of popular Western culture. Nineteen out of twenty yoga studios you visit provide no reference or education regarding the cultural, historical, or religious contexts from which these yogic practices sprang. Among the few studios that do, one often has to attend separate "special" meetings or workshops that are not part of the studio's regular schedule in order to access this important information. When references are provided in an actual studio session, they are often vague, anecdotal, or presented in a manner that's inaccessible to anyone without some degree of prior knowledge about the cultural or philosophical meanings undergirding these concepts.

My comments intend to go much deeper than the run-of-the-mill discussions we commonly encounter about the disrespectful acts of cooptation and appropriation that many ethnic groups are forced to routinely endure. To be clear, I am not and never have been an advocate for fundamentalism of any kind, nor am I a proponent of adopting outdated worldviews and practices of the past from any culture, nor am I anti-science or anti-intellectual. I have quite a few thoughts on the subjects named here and am highly opposed to all of them. However, those acts are only part of a much larger canvas, and the picture I am currently painting requires a more panoramic view. The point is that If contemporary spirituality is shifting away from these traditional frameworks, it is also pushing toward others. In this case, the shift has begun to place a very heavy emphasis upon scientific, technological, evidence-based conceptual models that tend to mock or disregard historically traditional frameworks hence the mocking and disrespectful term "woo-woo." I prefer to view these shifts as movements along a spectrum rather than opposites; they represent periods of change and transition in humanity's overarching worldview, and must be examined from above rather than below.

Our current place in history has begun to rely more and more heavily on the sciences and technology as the basis for understanding physical reality. The scientific model has provided humankind with the ability to understand and quantify our world in ways that were previously undreamed of for most of humanity's existence on the planet. The ushering in of the industrial age allowed us to begin to pair our scientific discoveries with technology as we began to truly shape and manipulate our world. More recently, the softer sciences like

Damon A. Powell, Ph.D.

sociology, anthropology, and ethnography have also shifted toward the use of more scientific models that place heavy emphasis on scientific observation and quantification, leading to a preference for the use of "evidence-based models." A similar shift is currently taking place in the metaphysical, new age, and self-help communities as scientific data and technological innovations become increasingly more integrated into the practices of leading teachers, coaches, healers, intuitives, and others. The supremacy of science is one of the reasons why "data" and "evidence" have become such an integral part of the current epoch that it has been labeled the "information age." We have more knowledge, evidence, and access to quantifiable data than ever before. This vast and ever-expanding collection of data has also supported the rapid development of ever more sophisticated technology. All of this is a good thing. But in my opinion, the pendulum has begun to swing too far. The system is becoming increasingly more imbalanced, and the imbalance is leaving no room for the existence of other colors within the spectrum. The sciences and technology have brought us a long way and can surely take us further, but we must not let their voices drown out all the others. Many of us have forgotten that scientific and evidence-based models are just that: models.

The philosopher Aristotle points out that the answers you get often depend upon the questions you ask. In modern parlance, we could say that the data you mine often depends upon the models you use to extract and interpret it. The scientific model is only one mode of inquiry among many, and it has its limitations just as the others do. All human knowledge is aesthetic to some degree, as it is grounded in experience and perception. Images, patterns, colors, sounds, emotions, and bodily sensations are the primary internal building blocks of thinking.

In most cases, this knowledge is fleshed out and translated into other modes of communication when it is transmitted to others. From this perspective, artists, scientists, musicians, and mathematicians all come to know through the use of subjective, non-quantitative realizations that they then communicate to others through their chosen discipline. If you listen to discussions about inspiration from a wide range of creators, you would be hard-pressed to distinguish scientists from artists, theologians from mathematicians, etc; the differences don't appear until each begins to present the final proofs as they account for their insights. In this respect, the only real differences between the arts and the sciences is that scientists

usually tend to strip any references regarding subjective influences when presenting their theories. However, this failure to acknowledge these intuitive perceptions does not negate the fact that they were a part of the original basis of their discovery.[1] One can easily find countless examples of this across almost all disciplines. If you read the accounts of various high-profile creators, you will find references to epiphanies, moments of sudden intuitive clarity, bursts of insight while in the shower or walking, identified as the catalysts for the development of many of the world's most cherished images, models, and theories. It is the mode of expression which determines how the final products are eventually presented to the world at large. Mathematicians present equations; visual artists offer pictures; psychiatrist's propose theories; yet one could easily categorize the source of the inspiration as mystical—or at the least irrational—because they predominantly emanate from a source beyond our conscious comprehension.

Scientific theories and evidence-based models are limited by their reliance upon physical and experiential phenomena. What can be observed and quantified is not necessarily all that can be known. The development of technology undergirds this premise because its creation usually allows humankind to further expand upon what we can observe and know. For thousands of years, the earth was believed to have been a flat surface. Gradually, through further observation of the world and the development of technologies like the telescope, ships, etc., this theory was proven inaccurate and replaced through the use and development of technologies that allowed humankind to observe and quantify more data, which then contradicted what we had been able to know and experience previously. But we often take these theories and run with them as if they are fixed representations of physical reality. They are merely representations and models based upon what we are currently able to perceive. Far too many of us are so entrenched in these models that we rule out the possibility of other ways of knowing not based on science and technology until they are validated by scientific or technological models. Many other alternatives are considered inferior, suspect, or outright false. Any methods or sources of knowledge that lie beyond the pale of what can be currently observed and experienced by the scientific model are relegated to the level of whimsy, mysticism, fantasy, or "woo woo."

However, the world is full of evidence to the contrary. There are countless records of peoples and civilizations that have been able to achieve feats that

modern science and technology are still unable to adequately explain or account for. The pyramids are a readily available example. The creators of these ancient edifices had access to knowledge and technological know-how that we have been thus far unable to comprehend despite all of the "advances" we believe we have made. In the metaphysical and new age community, many teachers and coaches have begun to incorporate scientific perspectives, evidence-based observations, and technological devices into their toolbox. The inclusion of these resources is a good thing; any available methods that assist your followers in making significant or easier progress along the path can make a big difference in their lives. But let's not forget that people have been making these kinds of advances without the aid of modern technology for thousands of years! In many cases, it may have taken more time to achieve certain results than it would have taken with the help of technology, but this is not a bad thing either. Our bodies, minds, and spirits can tune in and access knowledge and energies that science and technology have not accessed and may never gain access to. Human history has shown us that all of this has already been accessed without the use of anything other than discipline, time, and a quiet, open mind—yogis floating on thin air, intuitives channeling knowledge from the departed, everyday people seeing auras, and the list goes on.

Let's not forget that an argument from silence is no argument at all. Since science and technology have not been able to prove or disprove these phenomena, there is no basis from which one can justifiably ridicule or casually dismiss them, let alone label them "woo-woo." For thousands of years, practitioners have been reading auras. After photography was developed, when infrared scanning and similar technologies were finally able to produce similar results, the presence of auras was deemed legitimate. But aura reading was already real and legitimate long before any piece of technology imitated it. It was so real that those who practiced it didn't need a technological crutch to see an aura! We have become so entrenched in the scientific worldview and so reliant upon technology that we are unable to accept the possibility of any other kinds of knowledge. To question something's existence simply because you have no way of scientifically observing or duplicating it is an act of extreme hubris. In many ways, this attitude is the exact opposite of what science at its essence is truly aiming toward.

What we often forget is that people don't do things for generations for no reason. This fact is particularly relevant when reflecting upon the beliefs and

practices of ancient cultures. Special practitioners have been engaging in many of these practices for thousands of years. Not only that, but they have taken the time and effort to develop mythologies, sacred texts, complex rituals, and, in some cases, secret societies around these practices. Large-scale societies and cultural groups would not go through all the effort to preserve and pass down this kind of information for the sake of frivolous activities, especially when these practices often pull those who engage in them away from other more practical activities geared toward daily survival. This point is doubly relevant given the fact that some of these abilities and practices take years to develop. We find this phenomenon at work in every society.[2] If there were no real benefit from these kinds of practices, they would not have continued. They have played an integral role in humanity's evolution and will without a doubt continue to do so. The reason they were able to thrive and are still continued is that there is a palpable, persistent need and benefit to be gained from them. There is within each of us a psychological, biological, and spiritual proclivity toward connection with the supranatural.[3] We truly are spiritual beings having a physical experience. We are consciousness embodied in flesh. Our bodies are geared toward the aesthetic because that is what we came here to experience at this level of being. To feel, see, taste, smell, and hear with these bodies. But there is within each of us a connection to our true essence, and it is as integral to our existence as embodiment. In essence, we are hard-wired for the "woo woo."

All of us can connect with that essence, but most of us have not expended the effort needed to do so in any sustained, focused way. In every culture—both past and present—we seek out and elevate those who are found to have honed or developed certain abilities that appear to lie beyond the realms of human capacity and perception. We do so because of our innate wiring for connection with the divine. We need Spirit, God, the universe, the higher planes, etc. just like we need air. For thousands of years, our senses were the only vehicles we could make use of to fulfill this need; those who were able to hone and tune themselves to these higher frequencies were revered and supported. Science and technology have now begun to help us tap into and make use of these forces, but that does not give them the right to invalidate or validate their existence. We should be celebrating those who have dedicated themselves to the continuation and preservation of these practices while science and technology were attempting to catch up. Now we must begin to explore how these technologies can help make these

Damon A. Powell, Ph.D.

kinds of spiritual insights more accessible to all while simultaneously helping to speed up the rate at which these insights will be accessed by the masses of humanity. It is my prayer that these technological breakthroughs will help us progress much more quickly toward a long-awaited and much-needed spiritual evolution. The progressively diminishing role of organized religion has created a void that is shining more light upon the innate need for spiritual connection within us all. In some ways, science has usurped the role of religion in this capacity and is only now beginning to touch upon ways it might help to fulfill the hopes so many have invested in it.

Now that science is finally beginning to create some bridges between the psycho-spiritual and the technological, we must be very intentional about how we merge the two. Having access to certain abilities does not automatically grant the wisdom and discernment needed to responsibly and compassionately use them. The use of terms like "woo woo" and the tendency to disregard or diminish the traditions which have preserved these practices support my caution about exercising intentionality when merging the two. These traditions were protected, embedded within myths, and only revealed to those who had proven themselves to be spiritually advanced in part to ensure that access was not granted to those who lacked the spiritual maturity to use them in ways that would prove beneficial to all of humanity. Science and technology can help us, but they cannot save us. They are powerful tools, but they are just that: tools. They can aid us in our work, but they cannot do the work for us. Instead of attempting to decontextualize these practices or demythologize the traditions from which they come, merging them with and expanding them through science and technology would be a more respectful and culturally appropriate approach. It would also provide additional support to those who have limited experience with these kinds of practices by providing an expanded conceptual framework that would further enhance psycho-spiritual development. By embracing the "woo woo" we gain an opportunity to obtain the best from both worlds.

1 Ellen Dissanayake, "What Is Art For?" in Conversations Before the End of Time: Dialogues on Art, Life & Spiritual Renewal, by Suzi Gablik, (New York: Thames and Hudson, 1995), 87.

2 Ibid., 38.

3 Ibid., 40.

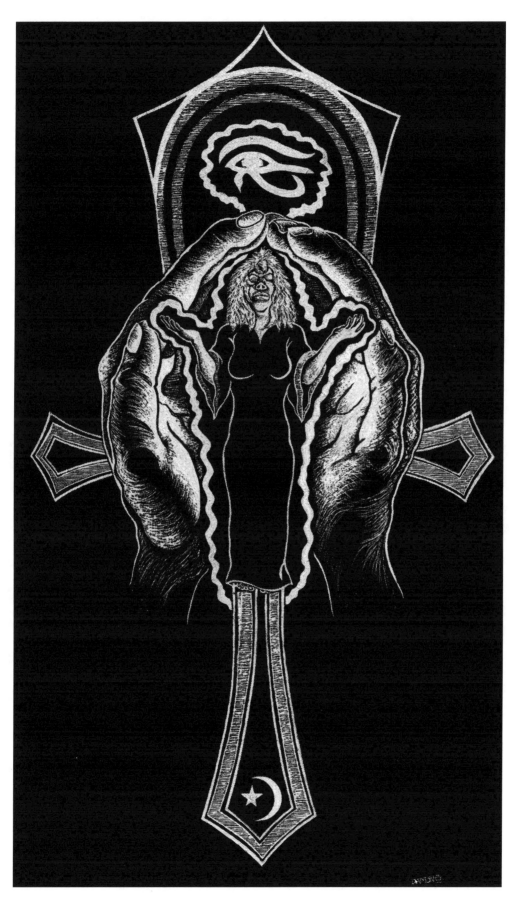

When We Pray 7

In the World and Of the World

When I initially committed myself to a life of ministry, I struggled a great deal with the inconsistencies I found between my daily life and who or how I wanted to be. I felt as if there was an enormous chasm between my self-imposed ideas about what and who a minister was supposed to be, and who and how I was in the world at that time. My initial response was to tighten the reins upon myself and do everything I could to avoid those aspects of myself that didn't fit the model. However, this eventually led to a great deal of guilt, self-loathing, and disappointment. As I entered seminary and began to delve more deeply into the theological aspects of my spirituality, I began to focus more and more on finding ways to take what I was learning and apply it to the questions and concerns of everyday living. My efforts in this area helped me to change my perspective and find ways to begin bridging what I felt to be an impassable chasm between my spirituality and my daily living. Since those early days, I have been a steadfast advocate for the development of practical spirituality. It makes no difference what kind of fantastic concepts you learn or how many varied states of higher consciousness you have reached— unless you can find concrete ways to apply the knowledge and experience you've acquired to the task of daily living. I am convinced that this should be the focus of our efforts as long as we have the privilege of consciousness within a body. If we are unable to find ways of applying to our daily lives the things we learn or experience, these insights should be set aside or temporarily disregarded. Life is for living, and if the things we experience and learn cannot help us to do so more fully, they hold very little positive value.

At the most fundamental level, our spirituality should support, sustain, and undergird our lives. It should not only enhance the living experience but help us to navigate the inevitable storms and difficulties of life in ways that promote further growth and enrich our overall life experience. It should give us hope, create resiliency, encourage balance, promote psychological integration and create a general sense of wholeness and well-being. Any beliefs or practices that do not do so should be set aside or discarded. Far too many of us are holding on to aspects of religious dogma or spiritual practices that create far more problems in our lives than they solve. We must abandon those pathogenic ways of being in favor of those which are more salugenic. But I must also caution against disregarding certain ideas just because we dislike or do not want to hear them. Some things I put away because I was simply

just not ready for them. I was not at a level of psycho-spiritual development that would allow me to appreciate or integrate them into my life at that time. However, Spirit has a way of bringing us back to retrieve them as we become more able to receive them. But this requires that we be open to the possibility of re-examining the lessons as they are brought back into our experiences. A healthy spirituality should also provide us with opportunities to stretch beyond our comfort zones and adopt changes that may be difficult to master but will ultimately prove to be in our best interests.

I contend that the fruits of such a spiritual life are intended not only for us but for the world. We are embodied souls, and our path back Spirit is not outside our bodies but within them. The path is not out of or to, but through. As we embrace sensual perception by going inward, we also notice that our inner depth becomes more easily reflected in the world around us. As within, so without. As we make progress on the path, we must share what we have gained for the benefit of those who have not yet reached our position. A truly robust spirituality should compel us to share with others both individually and collectively. It inspires us to co-create with Spirit in ways that benefit us individually and as a human family. To do so, we must be both active in the world and of the world. We exist not as separate entities but as part of a large and tightly woven tapestry. We know this to be true because our inner being confirms it. A rich and vibrant personal spirituality whispers it to us every day. It should fill you with compassion and provide you with opportunities to serve others. The light shining within cannot be covered. True light draws others and gives us the courage to stand up and out for them. It provides us with the courage needed to live out our values and offer our insights to those who will listen.

There is no such thing as private spirituality or personal piety. Each of us proclaims our ultimate values through the things we do and say—consciously or unconsciously. All you must do is take a brief examination of the kind and quality of manifestations you are bringing forth at any given moment. What you find will reflect your ultimate values. There is no separation. False dichotomies such as personal and private or church and state only erect false barriers that lack substance and power; they only provide a false sense of security. We speak, act, write, vote, and live out our ultimate values through every thought and deed. The issues of our hearts are pouring forth in every single moment. As within - so without. This notion of interconnection serves an

integral role in the process of co-creation. As created co-creators, we do so with the divine and with one another. Therefore, we have a responsibility to do so as consciously as we are able. Those of us who are farther along the path of conscious creation must hold space for those who have not yet reached our position. Whether we like it or even choose to acknowledge it, our destinies intertwine with those of every species on the planet and every member of the human family. We are engaged in a massive process of co-creative evolution.

Far too many spiritual teachers and religious traditions are advocating for a retreat from the world. In my opinion, some have become so heavenly oriented that they are no longer any earthly good. This perspective supports a spirituality that is completely ungrounded and undermines the realities of human embodiment. Some teachers advocate not becoming too involved with the world's problems or politics and even refuse to discuss their position on various issues to maintain the illusion of neutrality. Some of these teachers and traditions will encourage prayer for the world or divine intervention regarding specific issues – but have turned away from any forms of concrete action. Prayer is an essential and extremely powerful spiritual tool. It is one of—if not *the*—most important tools we have, but it should not be a substitute for taking prayerfully guided *action*. It is the first and most important response, but it is just the beginning. The very fact that you feel moved to concern regarding an issue is an important indicator that Spirit is leading you toward tangible action. Such action should find birth from time spent in prayer and contemplation regarding the concern. As persons of Spirit, we must always strive to balance prayer and contemplation with spirit-led action. Spirit-inspired action helps to assure that our responses are not knee-jerk reactions based on heightened emotions or the desire for revenge. Instead, we are guided by calm, deliberate, planned actions which are concerned for the best interests of all and not just one particular person or group.

The use of planned action means we must not only be in the world, but *of* the world. It is the experience of embodiment which our souls came here to grow and evolve within. Rather than retreat and run, our response should be one of full and total immersion within the world and all that our experiences here can teach us. After all, we are spiritual beings having a human experience. How can we possibly savor the experience if we stick our heads in the sand or run from it? Life is lived now and all our experiences—whether beautiful, grotesque, or mundane—become fuel for the growth of our souls.

Our senses, our bodies, and the experiences we have here are essential to the process of spiritual growth and the achievement of heightened levels of aesthetic embodiment. There can be nothing less than total immersion. As we progress further along the path of spiritual evolution, we not only have a responsibility to help uplift our fellow souls but to help uplift all life forms within the biosphere. However, this is not a fear-based attempt to control others based on fundamentalist doctrines and dogma, but rather a compassionate and authentic desire to serve other beings based on our sense of connection to all that is. This response should stem from our own soul's desire and an ever-deepening sense of compassion for all life.

As we immerse ourselves in the world, we become more attuned with it. This attunement increases our capacity for deeper aesthetic experience and deeper levels of spiritual embodiment as our souls become more fully integrated with our minds and bodies. The world, humankind and all its problems should be a part of this attunement. It inspires us to continually find ways we can creatively contribute to the alleviation of suffering and the establishment of equitable relations for all beings. This kind of spirituality leaves no place for extended seclusion from society nor purposefully ignoring the suffering we encounter within it. As Dr. Martin Luther King reminds us, "Human progress never rolls in on the wheels of inevitability; it comes through the tireless efforts of men willing to be co-workers with God...We must use time creatively, in the knowledge that time is always ripe to do right."[1]

The reactions of horror, dismay, and shock we experience as we examine the more grotesque aspects of human life provide us with a much-needed sense of contrast to the love, peace, and light we encounter in other life experiences. The very fact that we even notice this contrast is a glaring indicator that we are called upon by Spirit to take steps toward alleviating it.

When we do so, we become co-creators with Spirit in an ongoing process of inner and outer evolution. To apply co-creation in the metaphysical context, we could equate King's statements about "co-working with God" with the concept of conscious creation spoken of by a great many spiritual channels and teachers. The horror and dismay we feel when witnessing acts of sexism, classism, racism, fear, and other forms of hatred are in clear contrast to the sense of transcendence, mutuality, and interrelatedness we experience when in tune with Spirit. A truly connected and authentic spirituality does not lead us to ignore or retreat from these realities – but instead helps us to

realize that our individual fulfillment is connected to, and dependent upon the transformational resolution of these contrasts. Our task then is to work as conscious co-creators with Spirit in the transformation of the world's "isms" and inequities so that all of life may become one just as the divine is one.

We truly are our brother's and sister's keepers. Each of us is caught up within an inescapable web of interdependence and mutuality that encompasses all of humankind—past, present, and future. We owe a debt of gratitude to those who have come before us. Our current place in history requires that we actively participate in the co-creative evolution of all beings in the biosphere. To ensure that our living is not in vain, we must strive to leave a positive legacy for the souls who will inherit this reality in the distant future. Just as it is with our bodies and spirits, each of us is inexplicably intertwined with the other. We bear within us the capacity to mutually affect and be affected. What harms one inevitably harms all. We may not always readily feel the effects of this harm, but rest assured that it touches and corrodes us nonetheless. "Whatever one is or possesses, one owes to many others who have preceded him... each of us lives eternally in the red."[2] A truly rich and life-affirming spirituality brings this truth to our realization and continues to whisper it as we prayerfully engage in the work of conscious co-creation. By helping others, we also help ourselves. To come to such a realization and take no action as a result of it is to miss the mark completely

Prayer and contemplation are just the beginning. We must strive to become contemplatives in action. The world needs your voice. The world needs you to share your insights and perspective. The world needs your creative, spiritually inspired contributions. Active contemplatives strive to be in the world and of the world by immersing themselves fully in it. They do this by embracing their embodiment and drawing from its deep inner wells as they go about the process of daily living. Action for the sake of action often results in a great deal of activity that is often misdirected and ineffective. Inspired actions are co-creative. I say this because these actions come from emotion but are not driven by them; rather, they spring from an inner depth that tempers the tendency toward knee-jerk reactions brought about by the power of overwhelming emotions. Because inspired action comes from conscious co-creation, it does more than speak out against what is perceived to be problematic or inequitable. Inspired actions also push toward the manifestation of creative problem-solving strategies which push toward

resolutions. These are the features that characterize responses birthed from contemplative action.

Contemplative actions are very much akin to the concept of praxis. Praxis involves an ongoing process of action, reflection, and action. Contemplative action begins with prayer and contemplation; moves to spiritually inspired co-creative action followed by a period of reflection and integration; and then back into prayerful contemplation to continue the cycle. Contemplative action is aesthetic because it is both experiential and perceptive. It begins with suprasensuous experience as the catalyst for sensual experience, which is then perceived and apprehended through reflection and integration. Contemplative action is also a circular process with mechanisms for revision and refinement embedded within it. Let's examine this in context: Tyrone is listening to the news and becomes quite concerned about an issue he is informed about while listening. He recognizes his concern as a point of contrast between the incident and his ultimate values, and how his negative feelings have arisen. He begins to pray and meditate upon the issue as part of his ongoing spiritual practice. As he prays about the issue and what—if any—action he should take at this time, Tyrone is then guided to engage in spiritually inspired action. As he prayerfully engages in action, he receives confirmation that he is on the right path and continues. Afterward, he begins to prayerfully reflect upon his actions and how his experience has impacted both himself and others. He perceives the need for further steps and apprehends ways he can adjust, improve, or change. All of this becomes integrated into his perceptual experience as he once again begins the process of prayer and contemplation that will lead toward his next inspired action. Tyrone has now engaged in the practice of contemplative action.

The practice of contemplative action is very much akin to the conceptualization of yoga as being a practice because deeper levels of discovery and refinement are ever-possible in both. Because the body changes, yogis know that so too must the actions and subtleties of movement in each session. The ability to notice and work in and with the body to discover and accommodate these changes reinforces this conceptualization of yoga as a practice and helps to keep each encounter fresh and new. The same concept applies to contemplative action; it is an ongoing, ever-deepening, and expanding practice that is open to continual refinement and discovery. As prayer and contemplation deepen our capacity to embody more spiritual

light, the physical contexts and circumstances in which we attempt to employ contemplative action are always fresh and new as well. A moment of opportunity missed is never repeated, but Spirit does continuously provide us with opportunities to refine and apply our practice among the various persons and circumstances we encounter within the context of daily life. The ideal of contemplative action as a perpetual practice encourages openness, receptivity, and humility.

There is a very real and drastically needed place for global thinking, spiritual reflection, and inspired, spirit-led, co-creative action in the world today. Those who have not yet consciously stepped onto the path need our perspective, input, and action now more than ever. We have reached an evolutionary turning point that we cannot ignore. We cannot merely pray it away. We can't afford the luxury of ignoring it either. There is too much at stake for the encouragement of emotionally charged, fear-based reactions. Digging in and attempting to control or force others to adopt rigid dogmas and antiquated worldviews will only exacerbate situations that are already on the verge of becoming volatile. The solutions and growth we seek are not attainable through the exercise of unilateral power. We need spirit-led, inspired, informed, engaged, innovative, committed action that is relational and effective. We need spiritually attuned leaders who are committed to being both in the world and of the world. We need contemplatives in action.

1 Noel Leo Erskine, King Among the Theologians (Cleveland, Ohio: Pilgrim Press, 1994), 133.
2 Kenneth L. Smith and Ira G. Zepp. Jr., Search for the Beloved Community: The Thinking of Martin Luther King, Jr. (Valley Forge, Pennsylvania: Judson Press, 1998), 131.

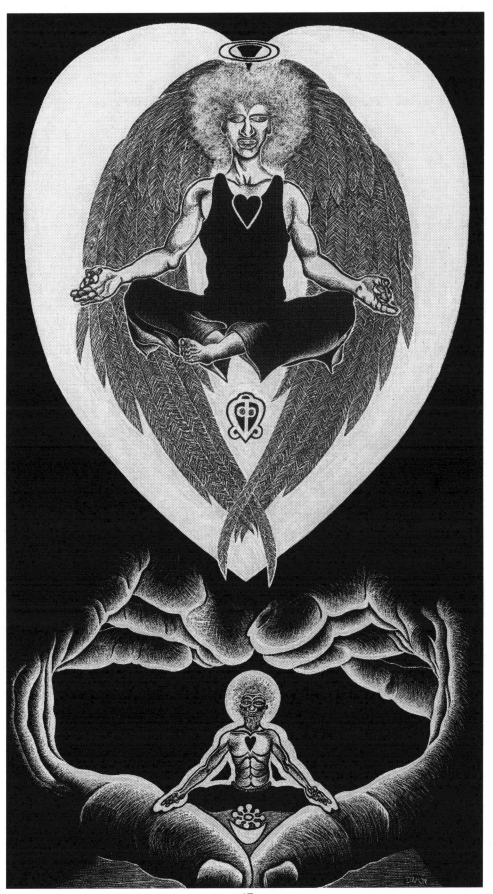

When We Pray 8

Coda
There is Only Love

When I began to download the initial inspiration for *When We Pray,* I had no idea that a series would follow. The initial inspiration came forth just as many others have: during my daily practice of prayer and meditation. I was sitting quietly, peacefully, feeling the warm and then cool pattern of my breath when I became of aware of a very distinct sense of presence surrounding me. It was not a sudden awareness but a slow, steady building that seemed to reveal itself progressively as it became increasingly more distinct all around me. I'm not sure how long the process took, but it was a slow and deliberate revelation that became increasingly more palpable. I felt no fear, only an ever more confident sense of comfort, ease, and genuine care and concern for the issues I was offering up for divine assistance. I somehow instinctively knew that my inner voice was heard, that Spirit was listening and was also compassionately concerned. As I poured forth my concerns, there was a gentle but firm sense of being held, or of being wrapped by divine hands and arms—that I was being stroked and soothed as a slumbering child would be by their mother. At the same time, I felt as if I was shielded and supported. Then it suddenly dawned on me that I was in God's hands and that this was the place I had occupied every time I prayed, but I had only now become aware of it. This realization of being enveloped in the hands of the divine resulted in the initial image of the series. As the weeks and months passed, signs came for another, and another...until I was confident that this transmission had run its course shortly after completing the seventh image.

Approximately eight months after completing the series I was compelled to create yet another image. I am an iconophile and have a love and thirst for imagery. During one of my afternoons in the studio, I began my fairly consistent practice of pulling up Google Images in my search engine and just typing in a random topic to see what kinds of images appear. I can't recall what the topic was, but my eyes were drawn to a picture of someone's hands forming the shape of a heart, and I experienced a sudden overflow of heat and love. "Knowing" is the only word to describe these numinous feelings—knowing and assurance that I was loved. That I was protected, cared for, kept, safe, home. And from that knowing, I was sure that this symbol of love must be made manifest through an image. As I began working on initial sketches for the work, my only thought was love. During the image's creation, I continued to receive this message of love. "There is only love."

There is only love. Love is all there is, all there has been, and there ever shall be. It sounds so cliché, but this simple truth is pregnant with potency and meaning. From an aesthetic standpoint, one could say that our senses stay tuned to the frequency of love. I say this because love must be experienced. Love is felt. Love is relational, and it is these qualities that also render it aesthetic. Love is an "I" whose existence necessitates a "Thou." This "I-Thou" relationship is an aesthetic orientation that encourages relation, rapport, empathy, identification, and engagement with that which is "it" or "other." In the process of engagement, the "it" transforms into a "Thou."[1] Authentic love requires that we exercise a relational response to life that is open, intuitive, imaginative, and empathic. There is no place in love for division. For authentic love, disconnection is never an option. This truth is not just a spiritual reality but a physical one as well. Quantum physics confirms this concept by reminding us that once two entities have interacted, they continue to influence one another no matter how far they may drift apart.[2]

The transcendental triad of aesthetics lies at the heart of love. The Good, the True, and the Beautiful are all subsumed in love, for love is the essence of goodness. There can be no authentic love in the absence of honesty and truth. Most assuredly above all else, love is supremely beautiful. This triad is relational, as the three mutually affect and support one another. You cannot experience one without to some degree also experiencing the others. The structure of their relationship ensures that the contrasting aspects of each support and enrich one another. This relationship of mutual enrichment permits each one to contribute to the value and richness of the other in a manner which enhances the strength of each individually—and so it is with love. Love is also anagogic in that it, too, lifts us. As we are lifted up by love we also lift and are lifted by others. This active web of relations lies at the heart of love and forces us to confront humanity's dominant conceptualization of love. We conceptualize love as a noun, but love is and ever shall be a verb. Because love, like creativity, requires manifestation. Love must be made visible, or it is not authentic love. All our conceptualizing and imaginings about love are simply much ado about nothing unless they become expressed in the form of concrete actions expressed in daily life. These expressions undergird our need to make love, fall in love, give love, welcome love, and actively experience it in all the myriad ways it can be given and received. As we engage in acts of love, we encounter the transcendentals.

Love is and has a vibration. It moves and radiates outward from the divine, showering itself upon all of creation. But just as with any other vibration we must tune in to receive it. Prayer and meditation allow us to perceive and receive the frequency of love. 528 Hertz is the dominant frequency in creation and has been dubbed the "Love Frequency" by scientists and spiritual practitioners.[3] This frequency of love has been proven to heal and restore damaged strands of DNA and is the prevailing answer when musicians are asked to identify the frequency they find most pleasing. The frequency of creation is the frequency of love because love is all there is. When we open ourselves to Spirit through meditation and prayer, we are attuning ourselves to love. The more we can receive, the greater our capacity to give. Staying within the flow of giving and receiving is one of the reasons why maintaining a daily practice of prayer and meditation is vitally important. The act of prayer is the most important initial step we can take to resolve any issue or problem. The Maharishi effect bears this out. The daily presence of people gathered in meditation has been proven to reduce violent crime, relieve feelings of stress and provide a host of other benefits to the surrounding communities where the groups were gathered for daily practice in transcendental meditation.[4] Prayer does change people and situations. But it does not relieve us from the responsibility of also taking concrete action.

From a metaphysical perspective, love never ends. But it is often born, dies, and is resurrected within the context of our material human experience. If we would simply take the time to look within, listen to our souls, and set free the love already within us, we would surprisingly find more of it everywhere we look. But we often travel through life crippled and completely lacking the very thing we crave so desperately. Love is free for the taking if we would just open ourselves to receive it. So, let love flow to you and through you. Love has no beginning or end because love is all there is.

1 Earle J. Coleman. "Beauty and the 'I' of Buber's Beholder" Religious Education, vol. 84, no. 1, Winter (1989), 140.

2 Barbara Holmes, Race and the Cosmos: An Invitation to View the World Differently (Harrisburg Pennsylvania: Trinity Press International, 2002), 148-149.

3 Attuned Vibrations. https://attunedvibrations.com/528hz/ (accessed November 24, 2018).

4 Maharishi University. https://research.mum.edu/maharishi-effect/reduced-violent-crime-in-washington-dc (accessed November 24, 2018).

Glossary

About the list

I have tried to define any specialized terms I have used within the chapter I initially refer to it in. In some cases, there were definitions and accompanying examples to help bring the concept to life. However, I realize that some terms have layered meanings that may not have been articulated clearly in the meditations. This list of terms is intended to support your grasp of the key concepts contained within the various meditations. These are not formal definitions or precise descriptions of concepts. I have covered many of them broadly and tailored them toward the contexts they were used in the preceding chapters.

The List

Aesthetics – a branch of philosophy that is concerned with human sensory perception, that has traditionally focused upon the perception of beauty or ideals concerning artistic taste.

Anagogy/Anagogical – a theological term used to describe a heightened state of spiritual awareness and attunement that lifts one up into higher spiritual states.

Apprehend/Apprehension – a kind of perception that is accompanied by a sudden flash of deep insight that is also uplifting and arresting.

Beautiful (The) – one of the three transcendentals which is often the focus of aesthetic inquiry.

Biosphere – a self-contained ecosystem that includes all living organisms.

Bisociative thinking – a process of thought which involves the combining of various concepts and elements into an overall framework or block of associated ideas.

Channel/Intuitive – someone who serves as a medium for a spirit and/or operates from a highly tuned sense of intuition that may or may not be associated with spiritual guides.

Cognitive – of the mind or related to the process of thought and mental capacity.

Counter-intuitive – against common sense or a natural inclination.

Embodiment – a metaphysical term relating to the spirit or higher-self inhabiting the physical body and senses.

Evidence-based – an approach to data use that emphasizes practical applications based upon the available data.

Foregrounding – bring something forth from the background or subconscious and give it priority in memory and thought.

Homospatial thinking - the ability to actively visualize of two or more things occupying the same space at the same time.

Hubris – excessive pride and defiance of the divine.

Icon – an image that is cherished or held sacred (usually reserved for a holy image but I apply the term in its broadest sense).

Iconophile – a lover or images or imagery.

Imago Dei – the image of God.

Janusian thought - the ability to hold two or more opposite or corresponding ideas in the mind at the same time.

Manifestation – the bringing forth of something abstract or non-physical into physical reality.

Modality – a particular form of expression or procedure.

Neuroscience – sciences which focus upon the brain and nervous system.

Paradigm – an underlying model or worldview.

Paradoxical – a statement or idea that is at the same time both correct and contradictory.

Pathogenic – a thought or belief system which is toxic or the cause of discomfort or pain (often rigid and highly structured).

Praxis – the application of theory or idea into practical daily life. This circular process involves reflection, action, and then further reflection and refinement in preparation for the next phase of action.

Prayer – the opening and movement of the heart and soul towards the divine.

Salugenic – a thought or belief system that is open, flexible and encourages increased well-being (usually responsive and open to change).

Sensual/Sensous – of or relating to the physical senses (physical sensation of the 5 senses).

Scratchboard – a board coated with fine clay, that can be covered over with ink and scratched into creating and image or mark.

Sign - a thing which points to something beyond its self. A physical image, mark, event, feeling...etc, that points to something else (usually simple and direct).

Supranatural – above or beyond the limits and laws of the nature.

Suprasensuous – above or beyond the limits of human physical sensory perception and experience.

Symbol – a mark, character or shape that is used to represent a material object or a set of abstract qualities. A combination of signs, or a complex sign.

Transcendent– beyond or through normal human experience, spiritual, not subject to the limitations the material universe.

Transcendentals (the) – The Good, The True, and The Beautiful. The three supreme philosophical concepts which are part of Plato's triad of higher forms. They are prior to and beyond human knowledge. In theological circles these three are prime attributes of the divine and are part of the Imago Dei.

Unilateral power – power or decision-making exercised by only one person or group (usually the victor in war, or the more powerful dominant person/group). Power exercised from the top down, without the agreement of others.

Reference List

Attuned Vibrations. https://attunedvibrations.com/528hz/ (accessed November 24, 2018).

Barth, Robert J., S.J. *"Theological Foundations of Coleridge on the Imagination"* in Symbolic Imagination. Fordham: Fordham University Press, 2001.

Berdyaev, Nicolas. The Beginning of The End. New York: Harper and Brothers Books, 1957.

Carroll, Noel. *"Art and Human Nature"* The Journal of Aesthetics and Art Criticism. 62, no.2 (Spring 2004): 95-105.

Coleman, Earle J. *"Beauty in the 'I' of Buber's Beholder"* Religious Education vol. 84, no. 1 (Winter 1989): 131-149.

_____. Creativity and Spirituality: Bonds between Art and Religion. Albany, New York: State University of New York Press,1998.

Crowley, Jonette. *"Soul Body Fusion"* the website for the Center for Creative

Consciousness. https://centerforcreativeconsciousness.com/soul-body-fusion-2/. (accessed August 12, 2018).

Crowther, Paul. *"Defining Art. Defending the Canon, Contesting Culture."* British Journal of Aesthetics. vol. 44, no. 4, (October 2004): 361-377.

Dissanayake, Ellen. Homo Aestheticus: Where Art Comes from and Why. Seattle: University of Washington Press, 1995.

_____. *"What is Art For?"* in, Conversations Before the End of Time: Dialogues on Art, Life & Spiritual Renewal. by Suzi Gablik. New York: Thames and Hudson, 1995.

Dyrness, William. *"Christian Imagination"* Image 15 (Fall 1996:) 84-94.

Erskine, Noel, Leo. King Among the Theologians. Cleveland, Ohio: Pilgrim Press, 1994.

Gaia Mind. http://www.gaiamind.com/m-star.html. (accessed on August 25, 2018).

Holmes, Barbara, A. Race, and the Cosmos: An Invitation to View the World Differently.

Harrisburg, Pennsylvania: Trinity Press International, 2002.

Jones, Leroi. Home: Social Essays. New Jersey: Ecco Press, 1998.

Maharishi University. https://research.mum.edu/maharishi-effect/reduced-violent-crime- in Washington-DC. (accessed November 24, 2018).

McIntyre, John. Faith, Theology and the Imagination. Edinburgh: Hansel Press, 1987.

Meeks, Wayne A. general ed. The Harper Collins Study Bible: New Revised Standard Version. New York: Harper Collins, 1989.

Mesle, C. Robert. "Aesthetic Value and Relational Power: An Essay on Personhood" Process Studies vol. 13 no. 1 (Spring, 1983): 59-70.

Mullin, Amy. "Moral Defects, Aesthetics Defects, and the Imagination." The Journal of Aesthetics and Art Criticism 62,:3 (Summer 2004): 249-259.

Nichols, Shaun. "Imagining and Believing: The Promise of a Single Code." The Journal of Aesthetics and Art Criticism 62, no. 2 (Spring 2004): 129-137.

Oxford University Press. Oxford English Living Dictionary (online). https://en.oxforddictionaries.com/definition/art. (accessed August.20, 2018).

Rivera, Alejandro Garcia. The Community of the Beautiful: A Theological Aesthetics. Collegeville, Minnesota: Liturgical Press, 1999.

Root Bernstein, Robert. "The Common Aesthetic Basis of Creativity in the Sciences and Arts."

Rendezvous 36, no. 1 (Fall 2001): 79-89.

Shusterman, Richard. Pragmatist Aesthetics: Living Beauty, Rethinking Art. 2nd ed. Lanham, Maryland: Rowman & Littlefield Publishers, 2000.

Smith, John E., Harry S. Stout and Kenneth P. Minkema. A Jonathan Edwards Reader. New Haven: Yale University Press, 1995.

Smith, Keneth L. and Ira G. Zepp, Jr. Search for the Beloved Community: The Thinking of Martin Luther King, Jr. Valley Forge, Pennsylvania: Judson Press, 1998.

Contact

To purchase prints of the illustrations in *When We Pray*
or view other works created by Dr. Powell, visit:

www.damonpowell.com
Email info@damonpowell.com
Phone 510.992.3737

Facebook: **Damon Powell -Artist & Theologian**
WordPress: **dpartistandtheologian**
Instagram: **dpartandtheo**
Twitter: **dpartandtheo**

Printed in the United States
By Bookmasters